IMAGES
of America

FORT SHERIDAN

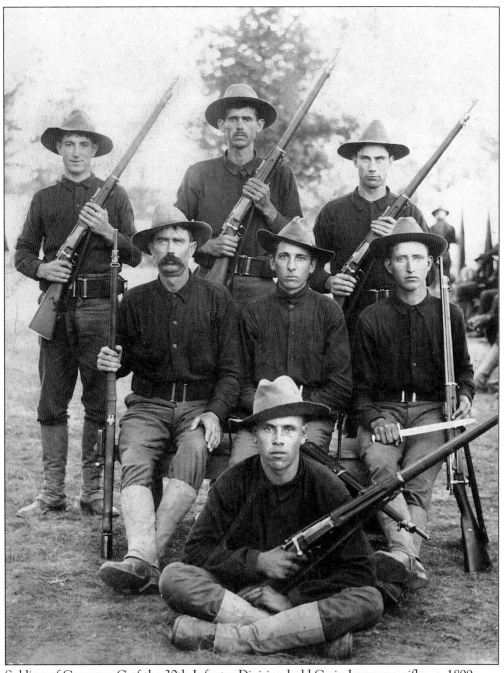

Soldiers of Company G of the 30th Infantry Division hold Craig-Jorgenson rifles, *c.* 1899.

IMAGES
of America

FORT
SHERIDAN

Diana Dretske

ARCADIA
PUBLISHING

Published by Arcadia Publishing
Charleston, South Carolina

Printed in the United States of America

Library of Congress Catalog Card Number: 2004098789

For all general information contact Arcadia Publishing at:
Telephone 843-853-2070
Fax 843-853-0044
E-mail sales@arcadiapublishing.com
For customer service and orders:
Toll-Free 1-888-313-2665

Visit us on the Internet at www.arcadiapublishing.com

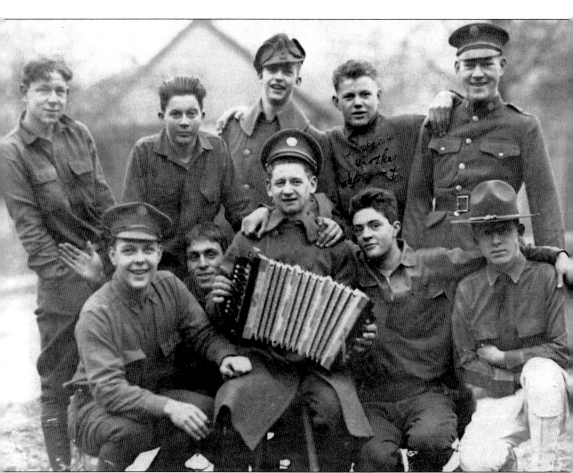

Soldiers of Company A of the 2nd Infantry pose, c.1930.

CONTENTS

ACKNOWLEDGMENTS

Thank you to my friends, family, and Lake County Discovery Museum staff and volunteers for their encouragement, and assistance with photo selection, scanning, and editing. Images in this book are from the collections of the Lake County Discovery Museum, Wauconda, Illinois, a department of the Lake County Forest Preserves.

Proceeds from the sale of this book go to support the Friends of the Lake County Discovery Museum.

This book is in memory of my father, Walter Dretske (1929-1994), who was stationed at Fort Sheridan in 1946.

INTRODUCTION

Over 100 years after its establishment, Fort Sheridan is going through a re-birth. Now largely a private community, the Fort has taken on a new life, a new vibrancy. It is hard to imagine the number of individuals who have come through its gates, but undoubtedly every one of them has in some way been impressed by this historic place.

Though it lies within the boundaries of Lake County, Illinois, Fort Sheridan's beginnings are tied more closely to Chicago than to the county it calls home. By 1870, Chicago had grown to 300,000, and was quickly becoming the commercial and railroad hub of the nation. But on October 8, 1871, tragedy struck—the Great Chicago Fire destroyed 18,000 buildings and left tens of thousands of people homeless. Chicago Mayor Roswell Mason declared martial law and put Gen. Philip Sheridan in charge. Sheridan (1831-1888), the son of Irish immigrants, was celebrated for his successful offensives during the Civil War. His troops built temporary shelters for the victims of the Chicago Fire and restored order.

Chicago was quickly re-built, but unrest continued in the form of labor strikes. One such strike was the national railroad strike which spread to Chicago in July 1877, and culminated in the deaths of 30 strikers. By the time of the Haymarket Riot of 1886, Chicago's wealthy businessmen, including Philip Armour, Marshall Field, and George Pullman, saw the makings of a working class revolution and became uneasy.

These influential businessmen, members of the Commercial Club, and some residents of Chicago's North Shore communities, discussed the possibility of the government establishing a military post near the city to protect their interests and to permanently maintain order. Philip Sheridan was also a member of the Club, and with his advice the Club purchased and donated over 600 acres of land near Highwood to the government. The first regiment, consisting of 84 men, arrived at the "Camp at Highwood" under the command of Maj. William Lyster in November 1887. On February 27, 1888, the site was officially re-named Fort Sheridan by Sheridan himself who was then Commanding General of the Army.

Brig. Gen. Samuel B. Holabird, Quartermaster General of the Army, awarded the commission for designing Fort Sheridan to his son's firm of Holabird and Roche. Founded in 1880, the Chicago architectural firm of Holabird and Roche would be significant in the development of early skyscrapers and especially influential in the architectural movement known as the "Chicago School." Their later projects included Soldier Field, the Chicago Board of Trade, and the Palmolive Building.

The first 64 buildings at Fort Sheridan were constructed between 1889 and 1895 out of an estimated 6 million bricks made on site out of clay mined from the bluffs. Prior to the Fort's creation this was the site of St. John's—a brick manufacturing village, located south of the Fort's historic district, which operated from 1844 to approximately 1865.

While Holabird and Roche were designing the buildings, nationally recognized landscape architect Ossian C. Simonds (1855-1931) was sighting the buildings and suggesting roads and paths to connect them. Simonds made use of the large tract of level land between the ravines for the parade grounds, and placed the military residences around this land to create a "hollow

square," reflecting earlier fort designs. The parade grounds provided space for military drilling, but also captured the essence of the prairie landscape. Using a technique called "broad view," Simonds employed irregular masses of trees and shrubs to create an indefinite border that made the open space of the parade grounds seem to extend beyond its boundaries.

One of the most interesting chapters in the Fort's history was the forced visit by Sioux warriors in 1890. After decades of conflict between settlers and Native Americans in the West, that conflict culminated in the tragedy at Wounded Knee, South Dakota on December 29, 1890. Afterward, a group of 19 Sioux warriors were escorted to Fort Sheridan. The idea was to show the warriors the newly constructed Fort in order to impress on them the strength of the U.S. military.

An unexpected result of this visit was that Buffalo Bill Cody (1846-1917) asked these Native Americans to join his "Wild West Show." The U.S. military agreed "provided they wanted to go." Many of the warriors signed on and left to tour Europe in Cody's show.

The first and only test of the Fort's true mission—to keep the peace—came in 1894. President Cleveland ordered troops to Chicago to establish law and order during the Pullman Strike.

Beginning in 1917 and 1926 respectively, Fort Sheridan became an Officers Training Camp, and Civilian Military Training Camp, preparing tens of thousands of young men for future wars. During World War II, the Fort became a Recruit Center for the peacetime draft, and assumed administrative control of prisoner of war camps in Illinois, Michigan, and Wisconsin; maintaining a German POW camp at the south end of the Fort.

From 1953 to the early 1970s, all Nike systems in the upper Midwest were supplied and underwent service maintenance at Fort Sheridan.

In 1984, the original 64 Holabird and Roche buildings, including the tower, barracks, and guardhouse, were among 94 buildings given National Landmark status. In 1988, the Department of Defense's Base Realignment and Closure Commission recommended the Fort's closure. However, the Fort continued administrative and logistical support, as well as Army Reserve facilities until its official closure on May 28, 1993.

Following the Fort's closure, buildings in its historic district have been renovated as private residences, while other areas have remained in use by the Army Reserves, and until recently the Naval Training Center Great Lakes. Additionally, 259 acres, including ravines, the golf course, and cemetery were deeded to the Lake County Forest Preserves.

This book is an illustrated journey through the life of an army post. The images are from the Fort Sheridan Collection of the Lake County Discovery Museum in Wauconda, Illinois, a department of the Lake County Forest Preserves. For reference, the army's building designations are listed when known.

One

VIEWS FROM THE FORT

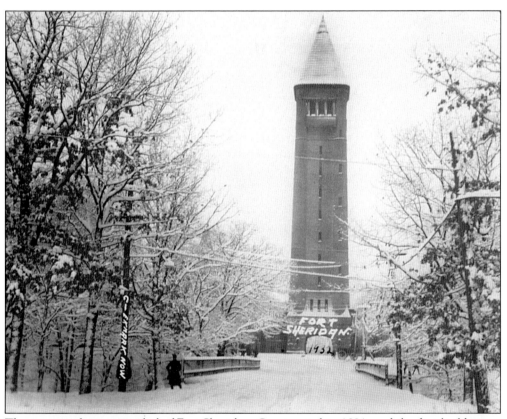

The tower is the very symbol of Fort Sheridan. Constructed in 1891, and the first building on site to be designated a National Historic Landmark in 1984, the tower served not only as a focal point for the Fort, but also as an elevated water storage tank to house the base's water supply and to provide water pressure. This 1932 view in winter, shows the tower from the south at its original height of 227 feet.

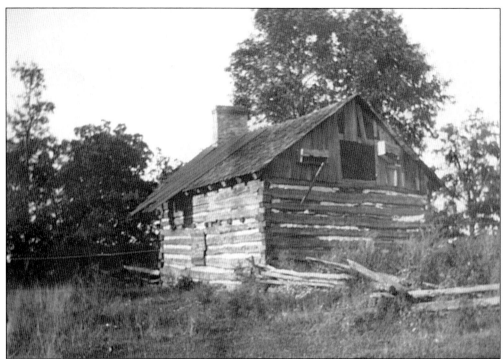

The land that is today Fort Sheridan was once part of the industrial village of St. John's and the town of Highwood. St. John's was a brick manufacturing and lake shipping port active from 1844 to c. 1865. The village produced 400,000 bricks annually from the clay deposits along the bluffs. Pictured here is the Sweeney Family cabin. The Sweeney's migrated from County Cork, Ireland in 1844, and purchased over 200 acres of land, including acreage on the site of Fort Sheridan.

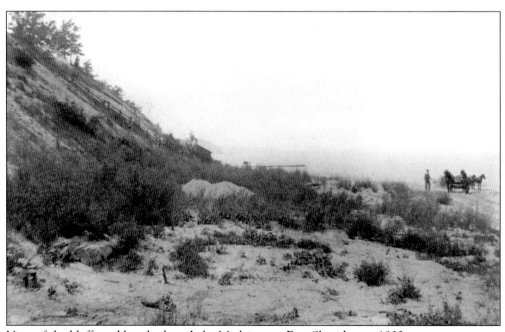

View of the bluffs and beach along Lake Michigan at Fort Sheridan, c. 1900.

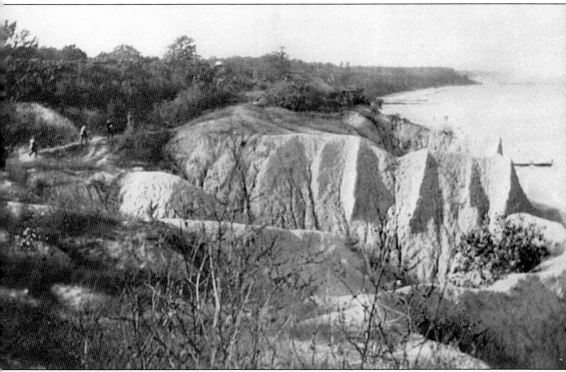

St. John's was located south of the Fort's historic district, overlooking Lake Michigan, and was stripped bare by extensive lumbering and scarred by the removal of clay from the bluffs. This picture shows the "Canyons of Fort Sheridan" with all the signs of severe soil erosion due to removal of vegetation. The industrial use left the site uninviting to potential developers after it was abandoned *c.* 1865. Some historians have suggested that the entire village washed away into Lake Michigan. In reality, the village grew stagnant and was abandoned due to a lack of passenger train service, and any remnants were removed by the U.S. Army in the late 1880s. With the building of the Fort, the army reopened the clay pits to make bricks, utilizing the readily available resource and cutting construction costs.

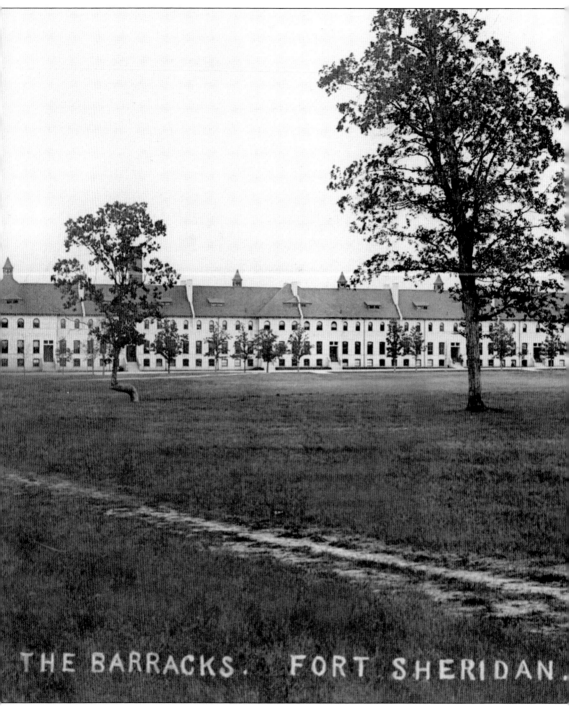

THE BARRACKS. FORT SHERIDAN.

Brig. Gen. Samuel B. Holabird, Quartermaster General of the Army and the person responsible for hiring architects, awarded the commission to design Fort Sheridan to his son's firm of Holabird and Roche. Later to be considered one of Chicago's most influential architectural firms, Holabird and Roche designed over 60 buildings, which were constructed between 1889 and 1895 out of an estimated six million bricks made on site out of clay mined from the bluffs.

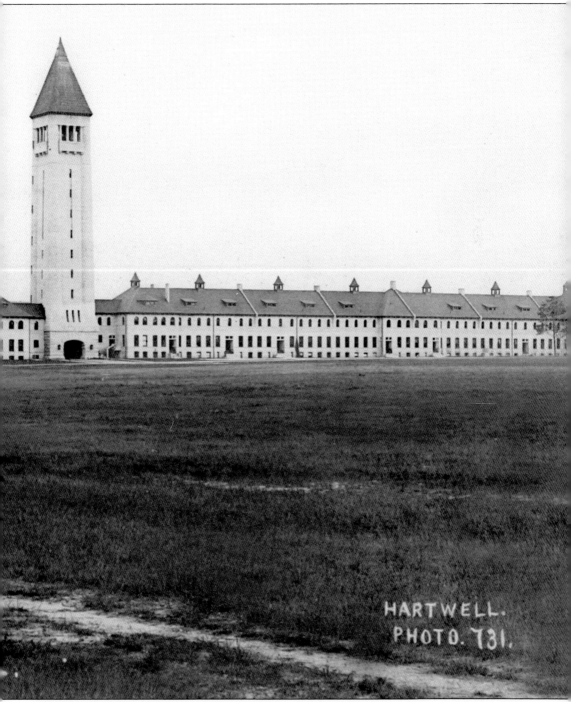

HARTWELL.
PHOTO. 731.

The Fort's landscape architect, the nationally recognized Ossian Cole Simonds, was a key contributor to the conception of the Fort's plan. Simonds advised Holabird and Roche on the most appropriate locations for their buildings. He used the large piece of level land between the two ravines for the parade grounds. Placing the military residences around this land created a "hollow square" which reflected earlier fort designs.

13

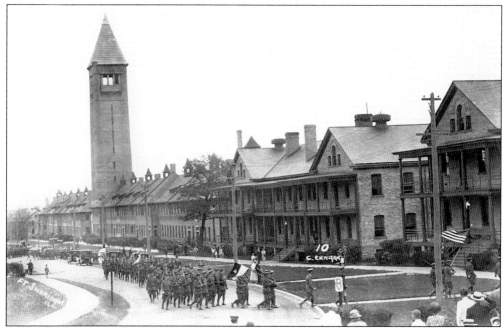

View of the tower and barracks row, c. 1925.

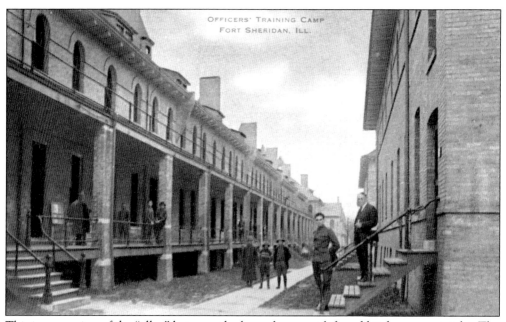

This is a rare view of the "alley" between the barracks row at left and kitchen row at right. The company kitchens were constructed in 1907 and 1908 for troops housed in the tower complex. These supplementary buildings were based on standard plans of the Quartermaster General. In 1967, the kitchen buildings were converted into offices.

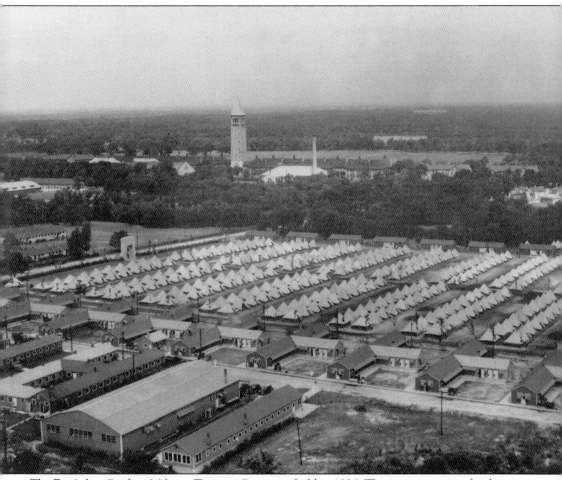

The Fort's first Civilian Military Training Camp was held in 1926. The camp was named in honor of Gen. Leonard Wood who, in 1913, created training camps to prepare the men who would fight in future wars. Camp Leonard Wood is distinguishable in this photograph by the white arch at left, denoting the camp's entrance, and the large grouping of tents. The camp existed from 1926 to 1939 for field and coastal anti-aircraft artillery training. The arch was donated in 1936 by the Chicago Historical Society, and razed in 1967 to make way for new housing.

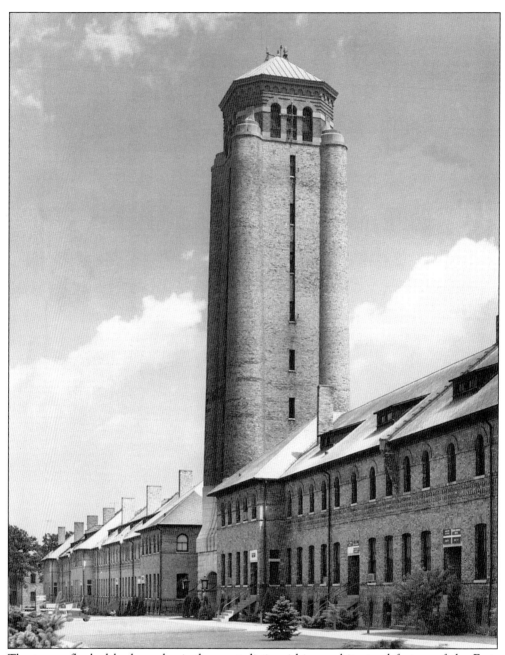

The tower, flanked by barracks, is the most distinguishing architectural feature of the Fort. When it was originally constructed in 1891 it was taller than the skyscrapers being built in Chicago's Loop. This view, c. 1960, shows the tower in its current, modified form after being overhauled in 1949.

Tower and barracks row viewed *c.* 1960.

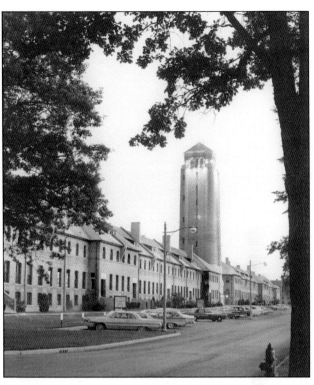

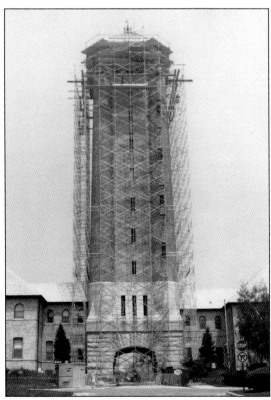

In 1949, a structural weakness was found in the roof and the tower was overhauled from its original height of 227 feet to its current height of 169 feet.

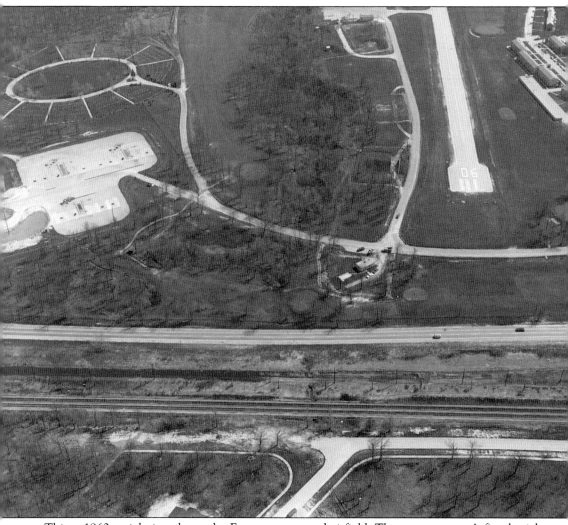

This c. 1960 aerial view shows the Fort cemetery and airfield. The post cemetery's first burial was in 1890. The cemetery remains an active one, but unlike a National Cemetery, burial is limited to retired members of the armed forces. Burials at the cemetery include three soldiers who served with Gen. George Custer, and nine German prisoners of war from World War II. The monument at the cemetery's entrance is to Chaplain Edward Vattman (1841-1919) who is buried beneath it. Father Vattman lived in Wilmette, Illinois, and was chaplain to the two Reserve Officer Training Camps at Fort Sheridan. The United States Army handles all burial inquiries and arrangements. The grounds are maintained by the Lake County Forest Preserves.

The army airfield, shown at right, was built in the early 1950s and its main use discontinued sometime after 1971. However, a helicopter landing pad was maintained into the 1990s.

Fort Sheridan's army airfield provided a 3,500-foot paved runway for planes used in anti-aircraft and coastal artillery training. In the late 1960s, the airfield was named Haley Army Airfield for Capt. Patrick Lawrence Haley, a helicopter pilot who was killed in action in Vietnam.

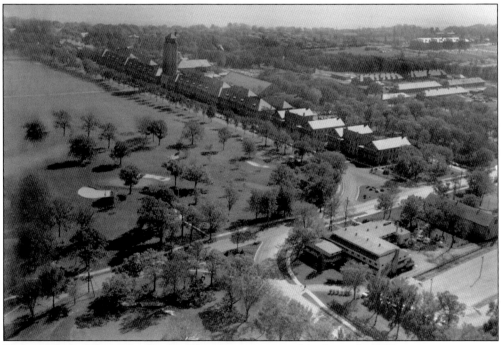

This aerial view shows the Fort's golf course, constructed in the early 1970s.

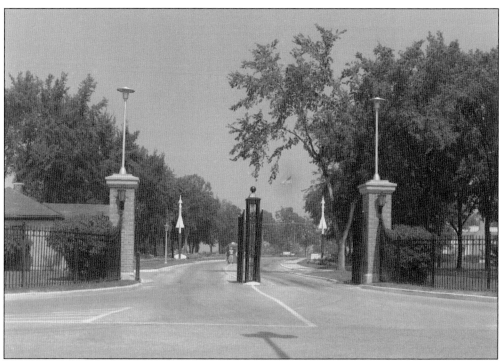

The main gate at Fort Sheridan, c. 1970.

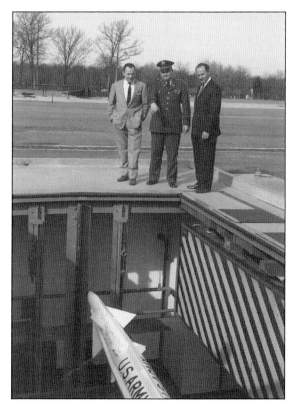

After World War II ended in 1945, the threat of air attack by the Soviet Union prompted the United States to build Nike air defense systems around its cities, military installations, and industries. The Chicago area had 23 Nike missile bases, including Fort Sheridan. Pictured at a Fort Sheridan silo on the north side of the base is Lt. Clarence Coates of the 517th Artillery. Coates is showing the Nike Ajax missiles to visitors Oraldo Boggia and John Cortesi. Boggia was an Italian exchange student at Northwestern University who was sponsored by the Highland Park Rotary Club of which Mr. Cortesi was a member.

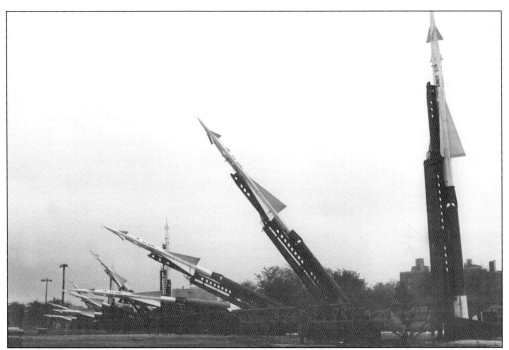

Nike missiles were the first operational, guided, surface-to-air missiles able to detect, track, and destroy enemy aircraft. Within a decade of their creation in 1953, they became less significant in the defense of the United States as the Soviet Union changed its military strategy away from bombers to Intercontinental Ballistic Missiles (ICBMs). Nike missiles were designed to strike enemy aircraft and not ballistic missiles. By 1974, all Nike missile sites were inactivated. Pictured in these photographs, c. 1960, are missiles in launch test patterns at Fort Sheridan.

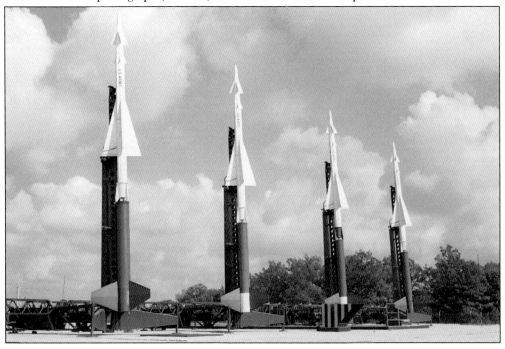

The Guard House and Stockade (Building 33) was one of the first buildings constructed at the Fort. It was built in 1890 and was designed to accommodate 72 prisoners. In 1905-06, the building was expanded to house an additional 48 prisoners. It continued to serve this function until 1970 when it was renovated as the post's museum—a function it retained until the Fort closed in 1993.

The sundial, pictured at right in the garden, was made by patients commemorating the Fort's Lovell General Hospital (1918-1920).

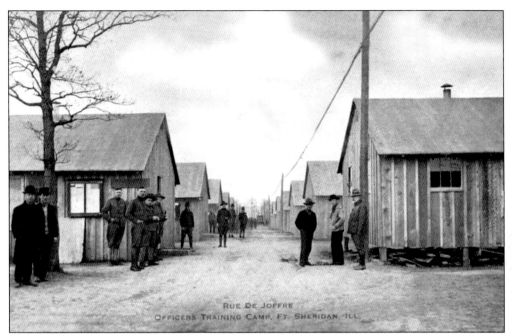

Temporary barracks constructed for the Reserve Officer Training Camps at Fort Sheridan. In 1917, these camps became the Fort's primary mission as set out by Gen. Leonard Wood who created the training camp program to prepare the men who would fight in future wars.

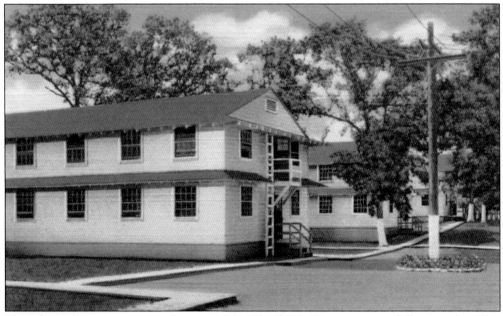

These barracks were constructed as part of the World War II temporary mobilization plan. This postcard view was printed in 1944.

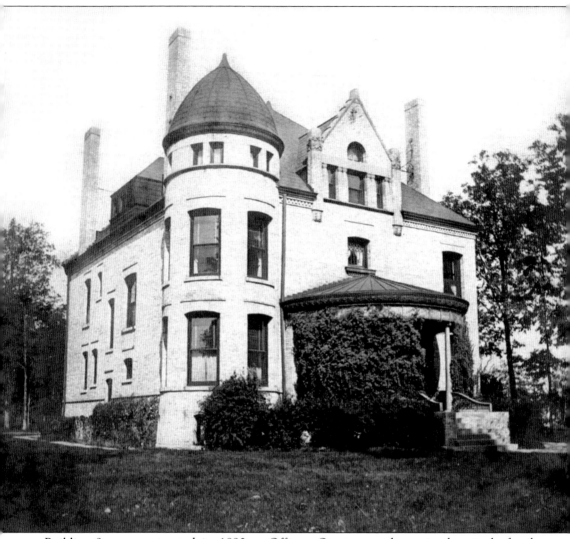

Building 9 was constructed in 1890 as Officers Quarters, and remained a single family residence for generals until the Fort's closure in 1993. It is significant not only for its design by the architectural firm of Holabird and Roche, but also for its location on the bluff above Lake Michigan within Logan Loop as part of landscape architect Ossian Cole Simonds' plan for the site.

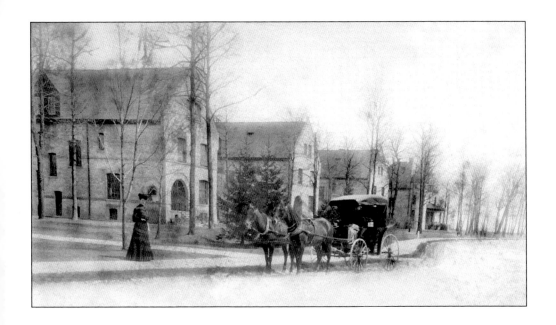

These two photographs show Officers Quarters shortly after being constructed between 1890 and 1892 on the east side of the Fort. The houses were originally designed as single-family captains' quarters and included rooms for servants on the third floor. Some of the houses remained single-family units until the Fort's closure, while others were altered in 1929 to accommodate two officers' families designated as Family Housing-Colonel.

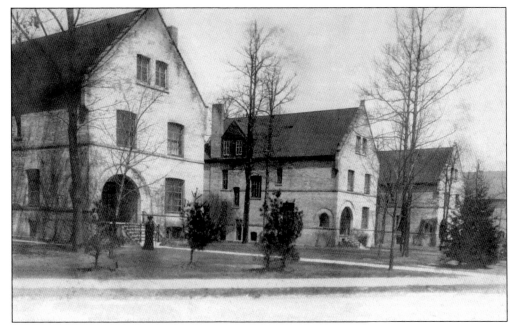

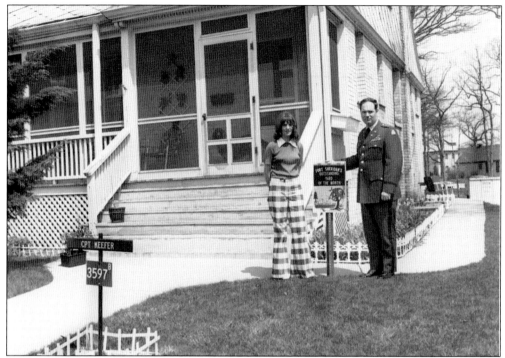

Pictured are Capt. and Mrs. Stephen Keefer in the front yard of their home (Building 35) on Lyster Road. They were the winners of the Fort Sheridan "Yard of the Month" for April 1973.

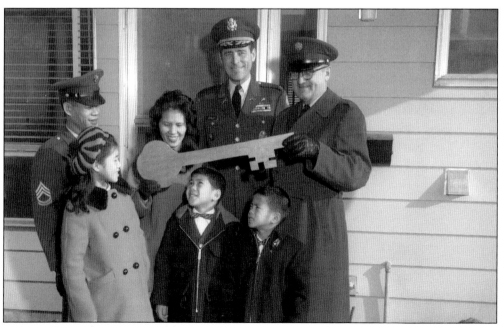

Sergeant First Class Pietro and his family received the "key" to their new home as the first residents of the new non-commissioned officers' government housing, December 1966. Pictured are the Pietro children: Lynda, Jimmie, and George, Sergeant First Class Pietro, Mrs. Pietro, Colonel Conley (Post Commander), and Sergeant Major Boys.

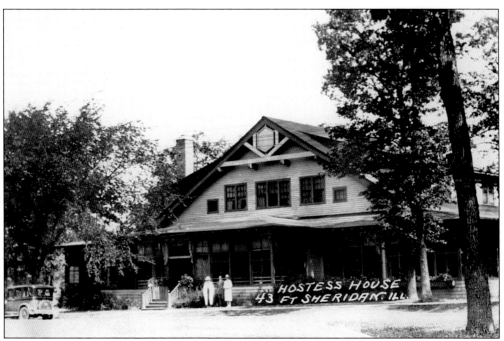

The Hostess House of the Young Women's Christian Association (YWCA) was constructed in 1919 at the west end of the parade grounds. The Hostess House provided recreation, a library, homemade food, and tea for soldiers. It was replaced by a Service Club (Building 205) at another location on site, in 1941.

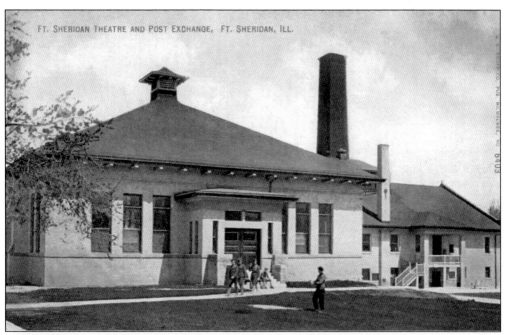

Built in 1891, Building 47 originally housed the mess hall and central heating plant. The building has been altered many times over the years and functioned as a chapel, gymnasium, theater, library, and finally as the post exchange. This photo was taken c. 1925.

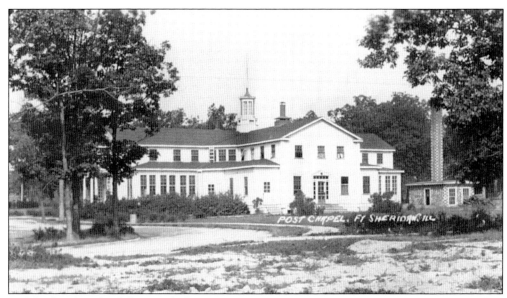

Holabird and Roche did not include a permanent chapel in their design plans for Fort Sheridan. Until about 1900, services were held in Building 47 (built in 1891 as the mess hall). Pictured is the post's first purpose-built chapel, constructed on the west end of the parade field. It was destroyed by fire in 1931.

This was one of two chapels completed in 1941 as part of the World War II temporary mobilization plan. It was located south of the tower on Patten Road.

Two

CAVALRY AND HORSE SHOWS

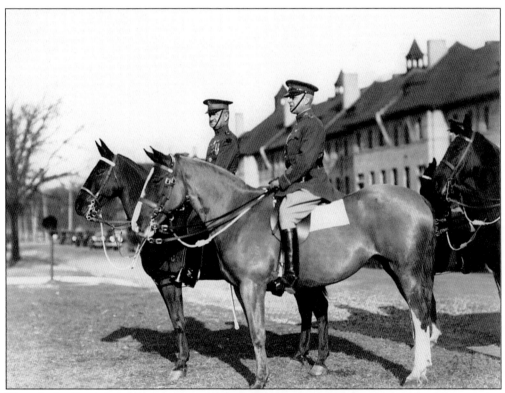

Though the first infantry troops arrived at Fort Sheridan in 1887, the first cavalry did not arrive until 1892. Fort Sheridan became known as a Cavalry Post, gaining a reputation for popularity with social elites. Notice the cavalry brand on the horse at center.

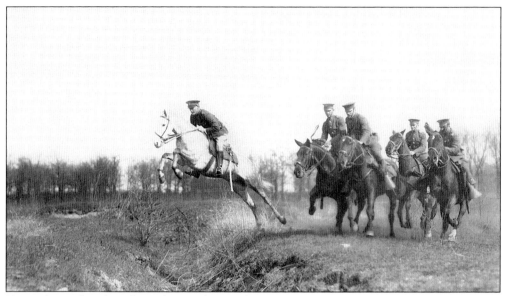

Horses have played a role in shaping human history since they were first domesticated nearly 5,000 years ago. They not only enabled faster communication and travel, but also proved decisive in military campaigns, allowing chariots and mounted soldiers an overwhelming advantage over foot-bound infantry. In this photo, cavalrymen train onsite, taking advantage of the open space and terrain of Fort Sheridan.

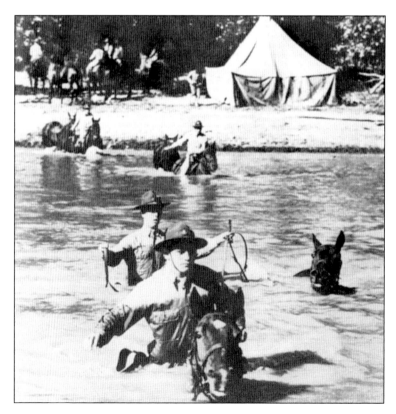

Though horses are inherently not designed to swim, they can do it. In the case of transporting troops and equipment across rivers, horses are a powerful ally.

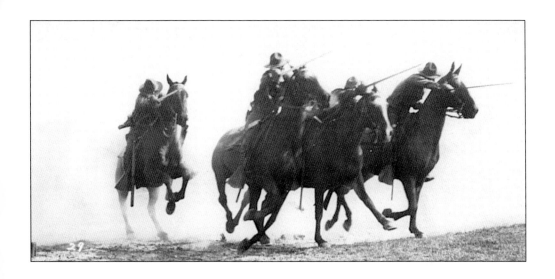

Cavalry charges have gone down in history as part of some of the most successful warfare strategies. The Gettysburg Campaign of July 1863 is full of examples of the effective use of mounted troops. Though by the time of the Civil War (1861-1865), many military men believed the days of the cavalry were over, but cavalry leaders knew that they were more important than ever. As illustrated in these photographs, the cavalry turned to training a modern horse-soldier, armed with saber and rifle, making him equally efficient, mounted or dismounted.

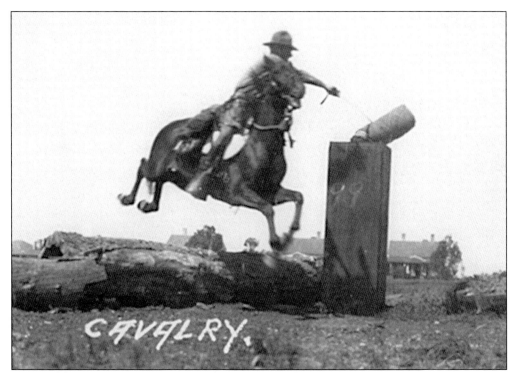

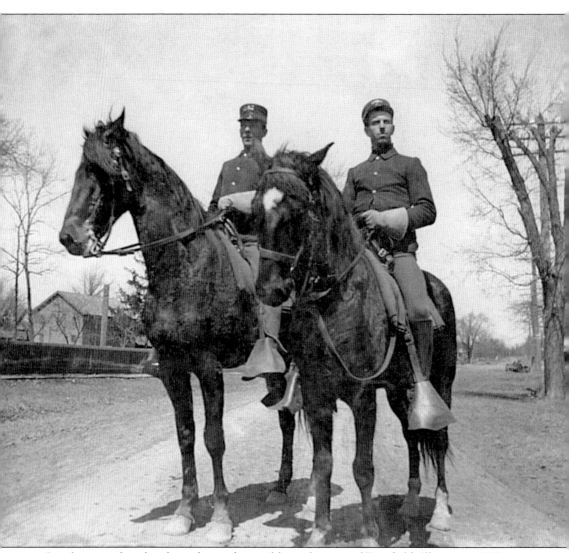

Cavalrymen take a break on their ride possibly in the area of Deerfield, Illinois, *c.* 1900.

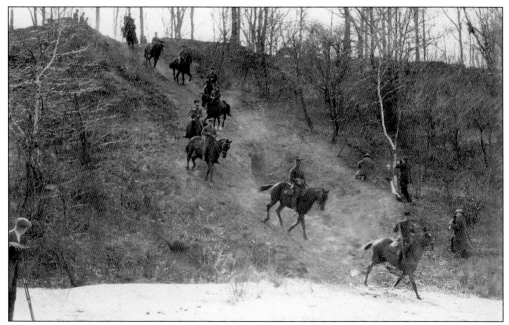

During the peacetime between the two World Wars, cavalrymen continued to train at the Fort. However, they also took time to exhibit their skills to the public as shown in this photograph of cavalry descending the bluff along Lake Michigan while several cameramen document their progress.

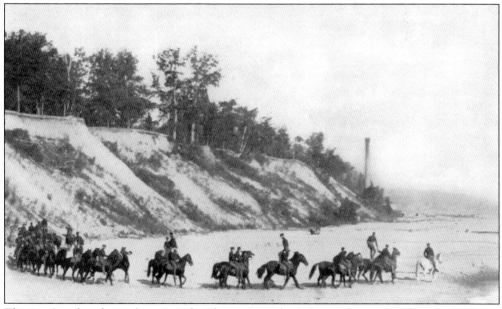

The 1st Cavalry, shown here "rough riding" along the Lake Michigan shoreline in 1897, was formed out of existing troops from the Illinois National Guard, and mustered into federal service as the 1st Illinois Volunteer Cavalry at Fort Sheridan. In 1899, it expanded, reorganized and was re-designated the 1st Cavalry. The unit was mustered out of federal service at Fort Sheridan in November 1916. Today, the 1st Battalion, 202nd Air Defense Artillery Regiment, traces its origins to this cavalry unit and the Illinois National Guard.

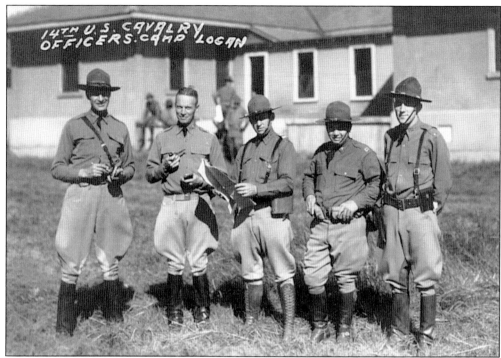

The 14th Cavalry was activated at Fort Sheridan in 1920. Cavalry officers pose during a training run at Camp Logan, Zion, c. 1930. Camp Logan (1893-1974) was a rifle and weapons training site for the Illinois National Guard, and was also used by Fort Sheridan and the Naval Training Center Great Lakes. It was located on over 200 acres of land north of Zion, and included a headquarters building, barracks, and mess hall.

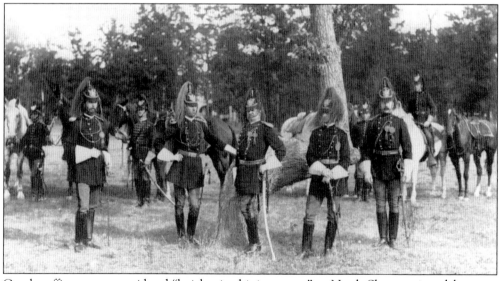

Cavalry officers were considered "knights in shining armor" to North Shore society debutantes who would accompany them to balls and receptions. Pictured are officers of the Cavalry Squadron, 1897: (foreground from left to right) Captain R.P.P. Wainwright, 1st Lieutenant M.E. Davis, Major C.D. Viele, 2nd Lieutenant W.M. Whitman, and 2nd Lieutenant R.C. Williams.

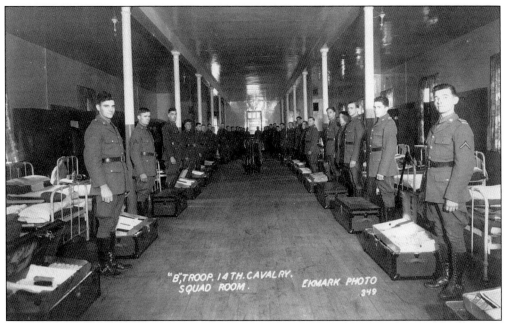

The 14th Cavalry "squad room" c. 1925 in one of the cavalry barracks located in Buildings 81 and 82 at the west end of tower row. They were constructed in 1905 of cream-colored common brick, and designed by the Office of the Quartermaster General. When the Fort closed in 1993, Building 81 was being used as a General Purpose Administration Building. In 1968, Building 82 was remodeled to function as Army Headquarters, and by the time of the Fort's closing was used as an Army Reserve Center.

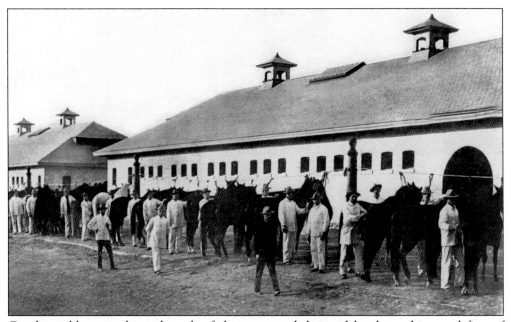

Cavalry stables were located south of the tower and designed by the architectural firm of Holabird and Roche. Two stable buildings were constructed in 1890, and after the arrival of cavalry troops in 1892, four more buildings were constructed.

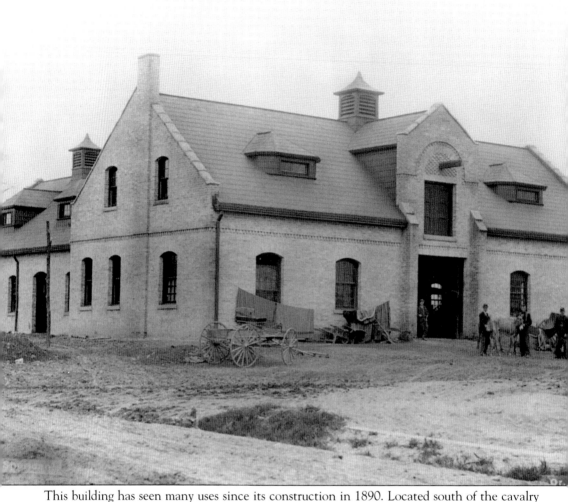

This building has seen many uses since its construction in 1890. Located south of the cavalry barracks on Lyster Road, Building 38 was constructed as a veterinary hospital and was one of the first buildings completed at the Fort. In 1918, it was converted into stables. Following World War II, the structure was modified for use as a post exchange and cafeteria. In 1969, it received its final alteration and served as a post office until the Fort's closure in 1993.

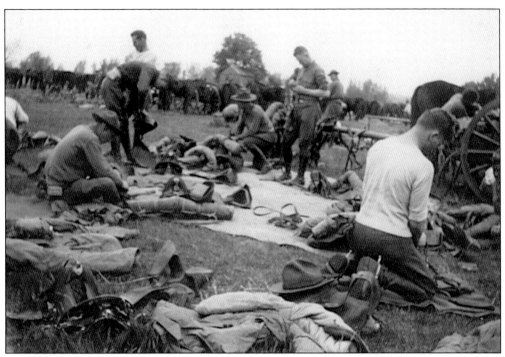

Cavalrymen clean harnesses, c. 1925.

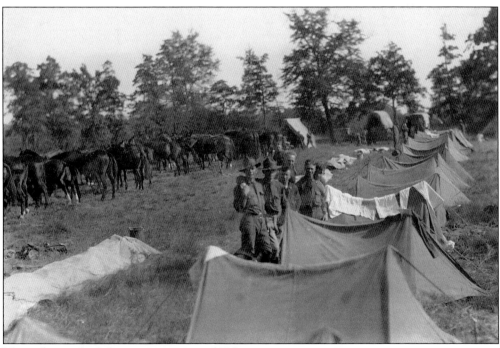

View of a cavalry hike encampment, c. 1925.

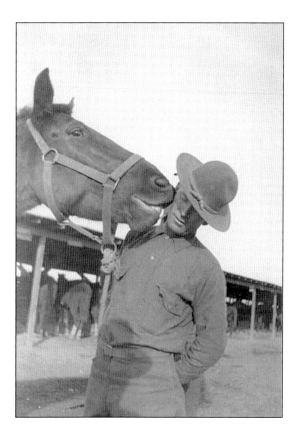

An army may march on its stomach, but a cavalry marches on its horses. One of the first things cavalrymen were taught was to take better care of their horses than themselves.

A cavalryman tends to his horse during a hike, c. 1930.

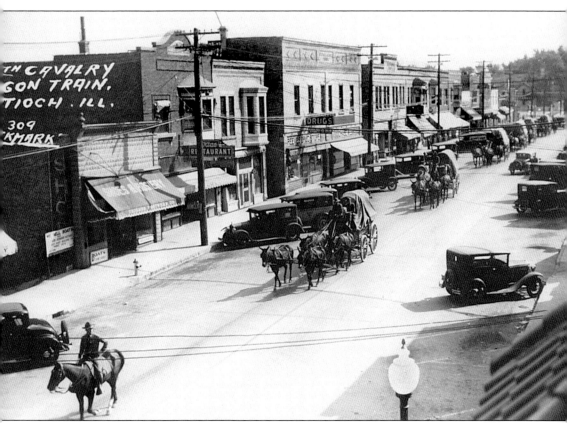

Troops from Fort Sheridan were often seen on hikes away from the Fort, and overall were held in high regard by local residents. Military installations were a mixed blessing to neighboring communities, bringing a boon of new businesses, but also the occasional brawl in a local tavern. Here, the 14th Cavalry are hiking through Antioch's business district, c. 1925. Antioch, located in northwest Lake County, was a popular resort town and en route to Wisconsin military campsites.

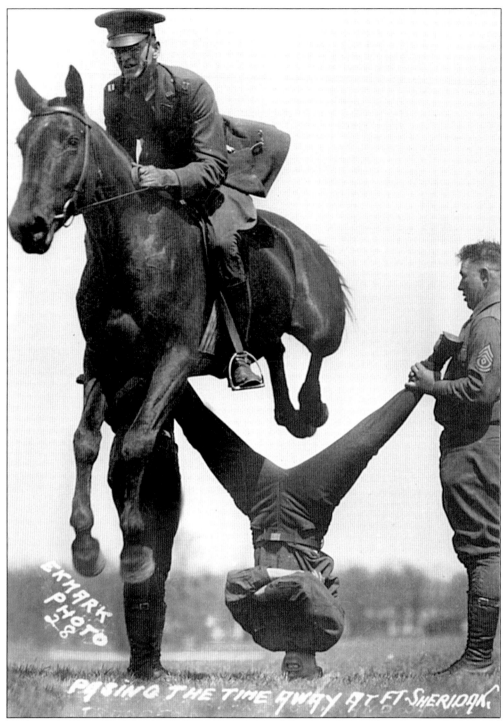

By the 1920s, Fort Sheridan had taken on a country club atmosphere. Though troops continued to train, cavalry officers in particular showcased their talents in horse shows and polo matches. Some of the stunts performed to cheering crowds illustrated the fearlessness and precision of these horsemen. Shown here is one of the more ambitious stunts caught on film, *c.* 1925.

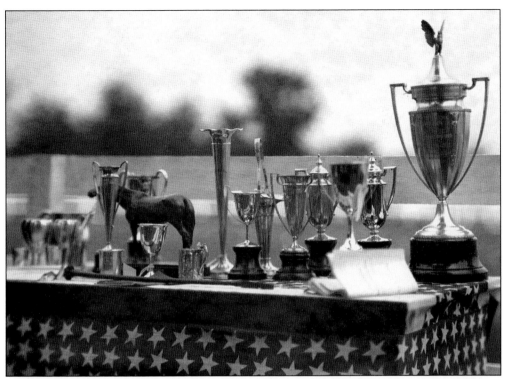

Like military honors, trophies awarded at horse shows were highly valued and lauded. Pictured here is a display of trophies ready for the victors at a *c.* 1930 horse show at Fort Sheridan.

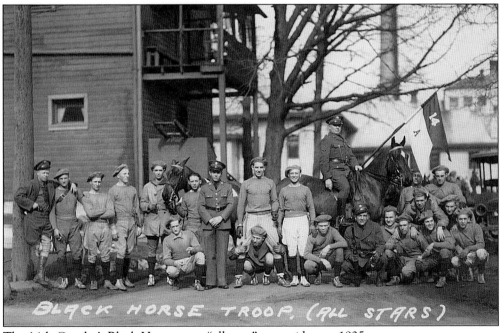

BLACK HORSE TROOP. (ALL STARS)

The 14th Cavalry's Black Horse troop "all stars" stunt riders, *c.* 1925.

First Lt. Mancel Kennedy leads the 14th Cavalry "all stars" to a performance at Fort Sheridan.

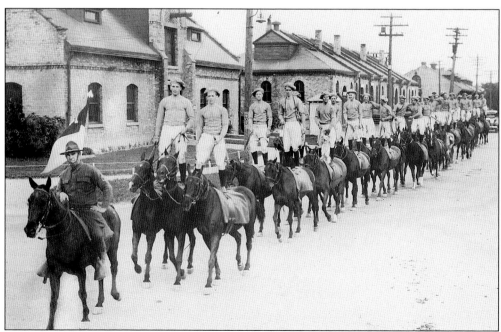

The 14th Cavalry on Lyster Road is pictured next to the stables, c. 1931.

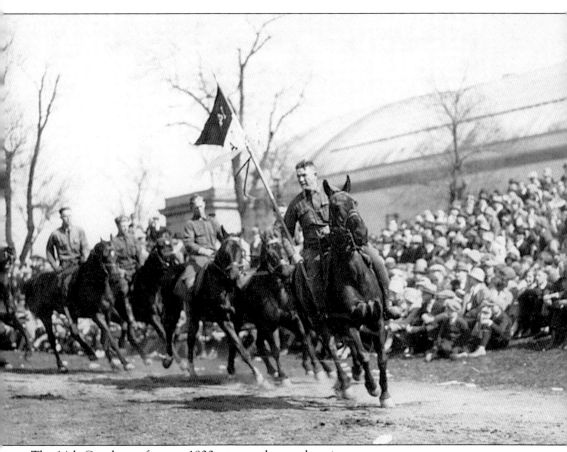

The 14th Cavalry perform, *c.* 1930, at an unknown location.

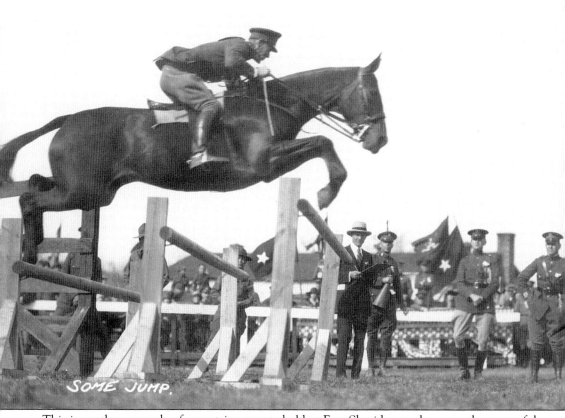

SOME JUMP.

This is another example of equestrian events held at Fort Sheridan to showcase the masterful horsemanship of the 14th Cavalry, c. 1930.

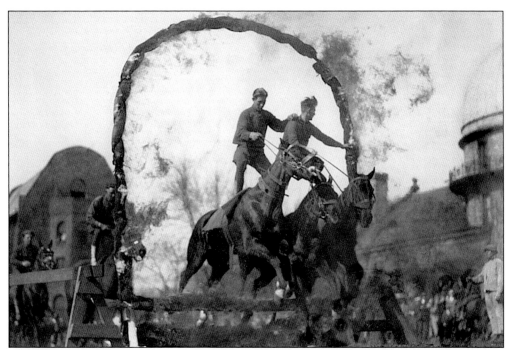

No challenge too great, these cavalrymen ride three horses through an arch of flames. The location is unknown, c. 1930.

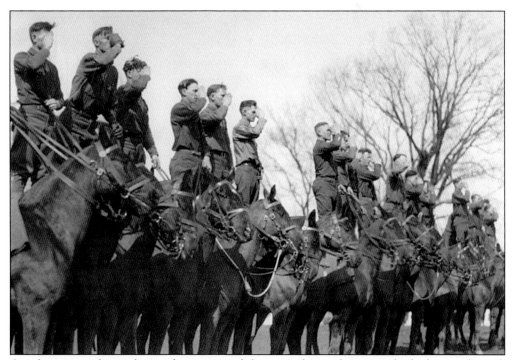

Cavalry stunt riders, saluting during one of the many horse shows at which they performed. These teams also performed exhibitions at Soldier Field in Chicago and at the Chicago World's Fair in 1933.

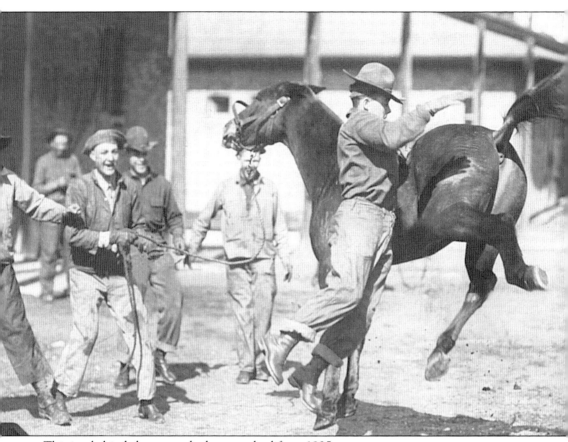

This is a behind-the-scenes look at cavalry life, c. 1925.

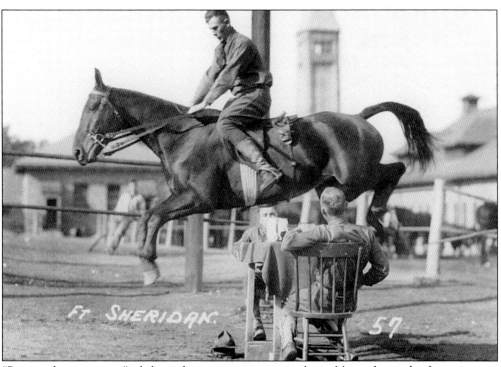

"Passing the time away" while perfecting stunt jumps in the stable yards, south of tower row.

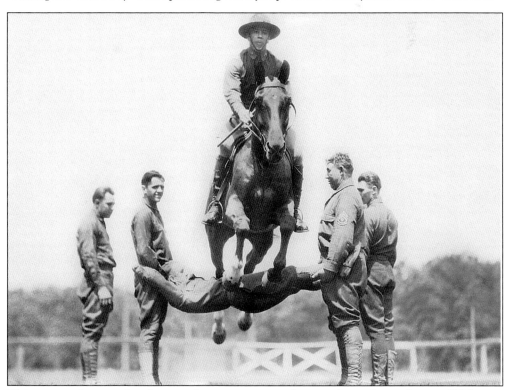

This was another peculiar "training" exercise to woo the crowds at a horse show, c. 1925.

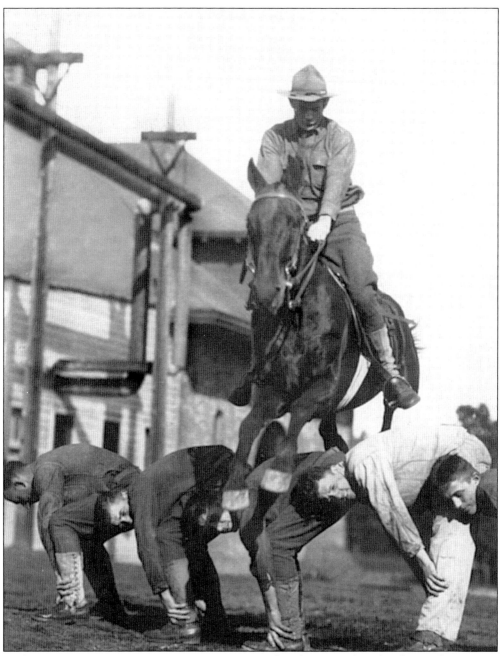

With so many jump arrangements, it is no wonder the Fort Sheridan horse shows were popular with area residents. The shows, which were held from 1925 to 1939, not only showcased horsemanship and bravery, but also respect for the animal that played a key role in warfare over centuries.

Three

LIFE AT THE FORT

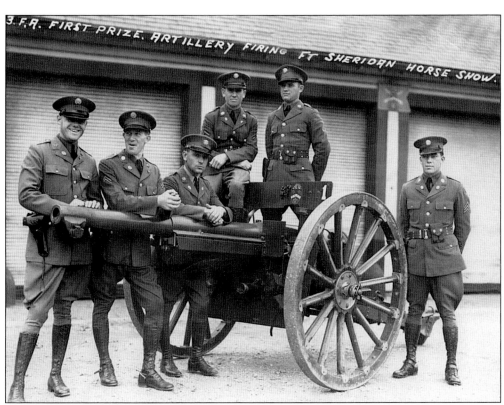

"D" Battery, 3rd Field Artillery, were winners of the first prize for artillery firing at the Fort Sheridan Horse Show, 1932.

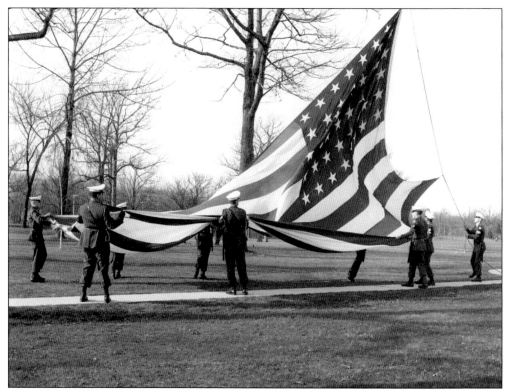

A flag ceremony, Fort Sheridan, 1963.

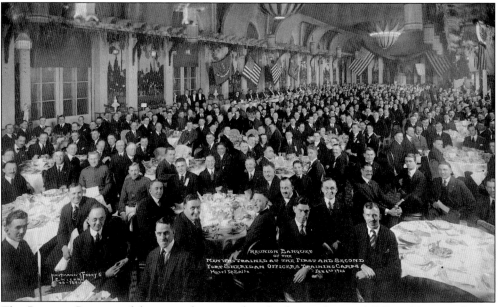

This Reunion Banquet of the men who trained at the first and second Officer Training Camps at Fort Sheridan was held at the Hotel LaSalle, Chicago, in February 1920. The first of these training camps was held at Fort Sheridan in 1917. Gen. Leonard Wood created the training camp program to prepare the men who would fight in future wars.

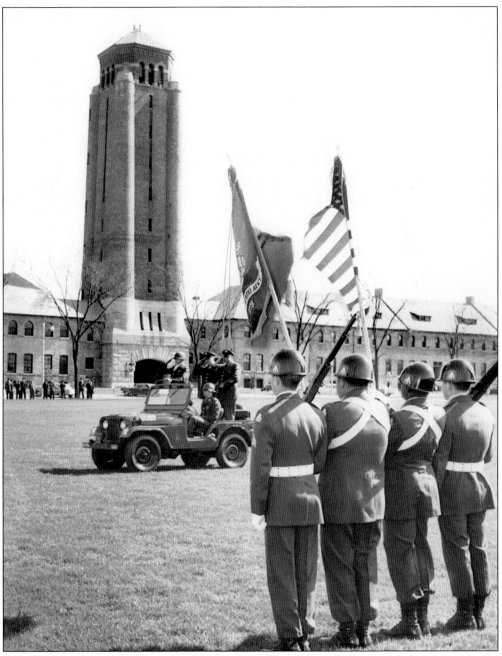

M. Sgt. James N. Barrios salutes the Color Guard as he reviews the troops during retirement ceremonies held for him at Fort Sheridan, 1965.

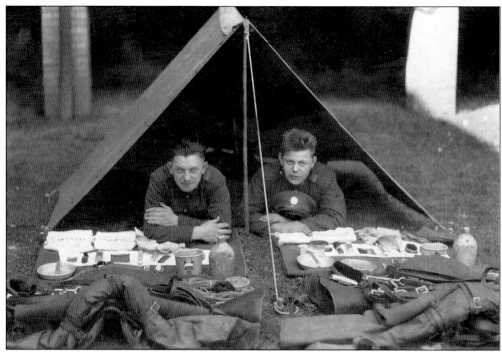

Cavalrymen rest in a pup tent during a hike, *c.* 1925.

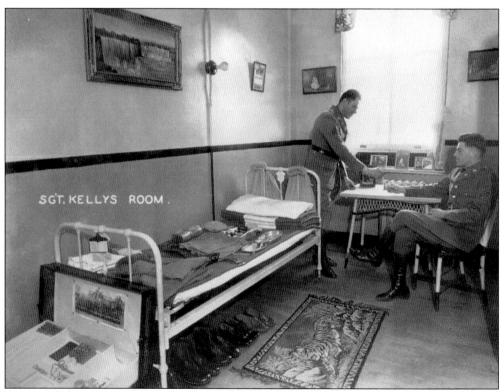

SGT. KELLYS ROOM.

Sergeant Kelly's quarters, Fort Sheridan, are pictured *c.* 1925.

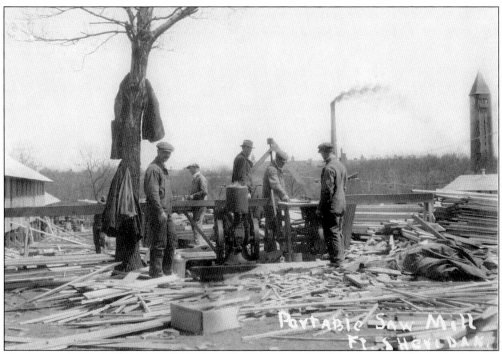

Workers and a portable sawmill were brought in to help build temporary barracks for the first Officer Military Training Camp, 1917.

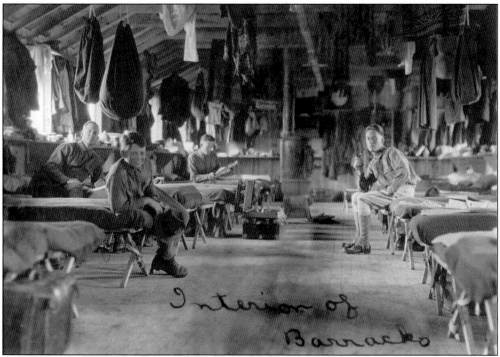

An interior view of the temporary barracks for the Officer Military Training Camp is pictured above, c. 1917.

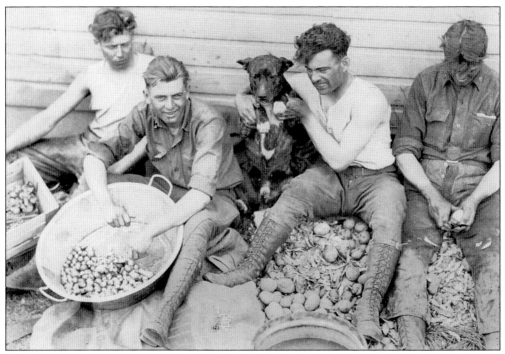

Members of the 3rd Field Artillery peel potatoes for kitchen duty, c. 1933.

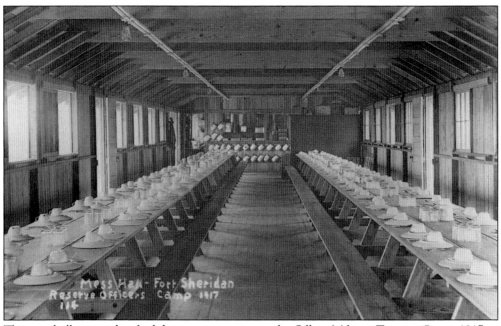

The mess hall prepared to feed the men in training at the Officer Military Training Camp, 1917.

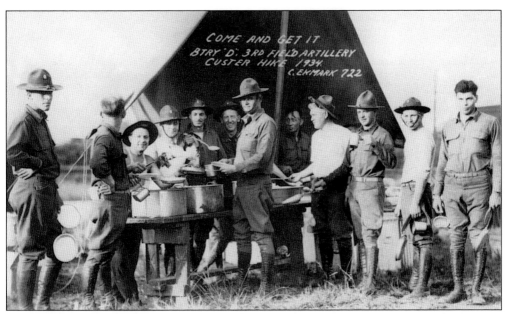

"Come and Get It" for Battery D of the 3rd Field Artillery, on hike to Fort Custer, Kalamazoo, Michigan, 1934.

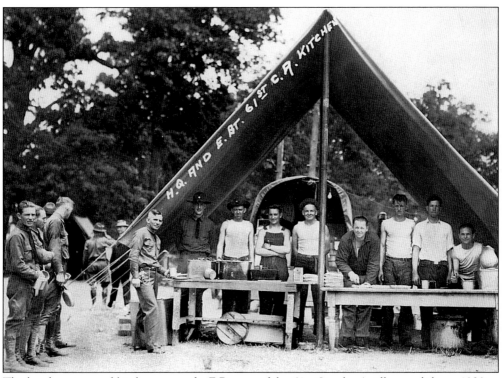

The headquarters and kitchen set-up for E Battery of the 61st Cavalry Artillery on hike, *c.* 1930.

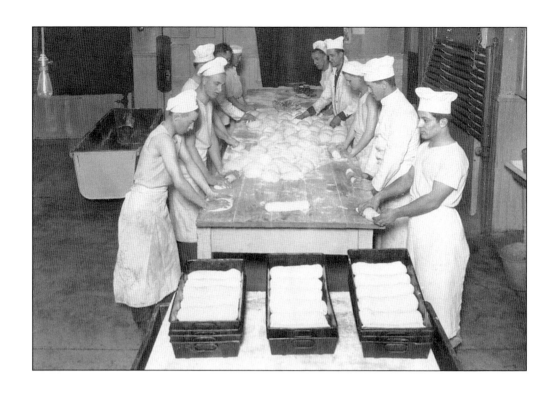

Bakers in training at Fort Sheridan, *c.* 1930.

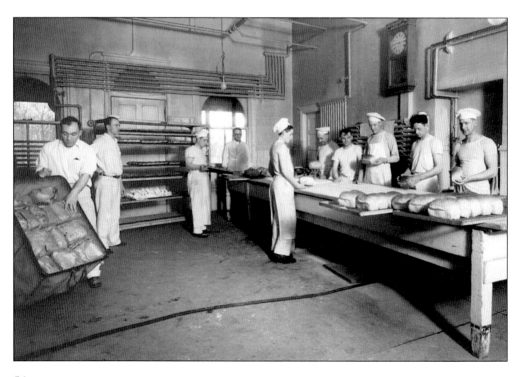

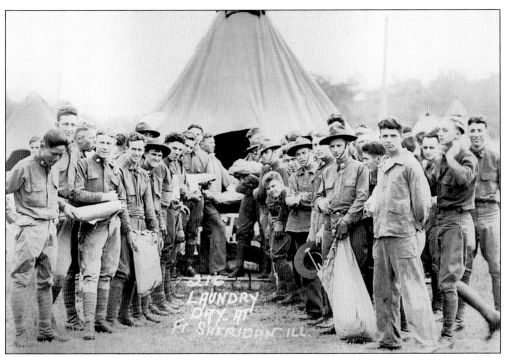

Recruits are ready for laundry day at the Fort's Civilian Military Training Camp, *c.* 1926.

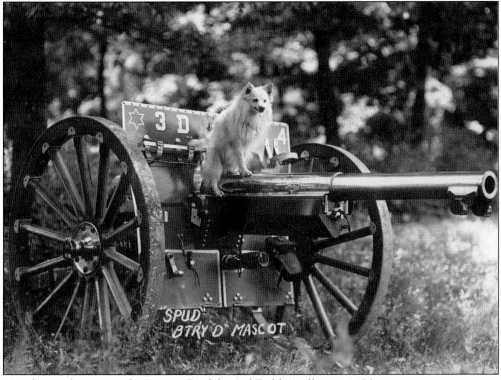

"Spud" was the mascot for Battery D of the 3rd Field Artillery, *c.* 1933.

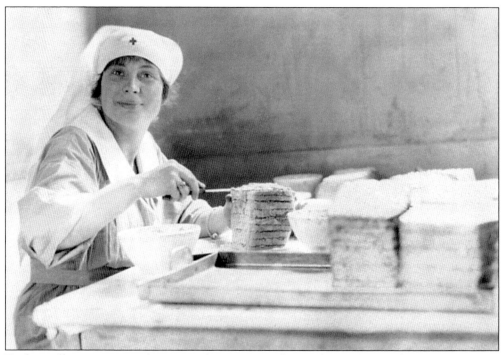

Traditionally women served as nurses during times of war. This unidentified woman may have been a nurse at the Fort's Lovell General Hospital, c. 1920.

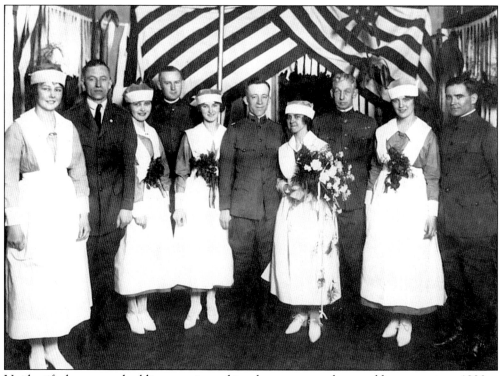

Unidentified nurses and soldiers are pictured in what appears to be a wedding portrait, c. 1920.

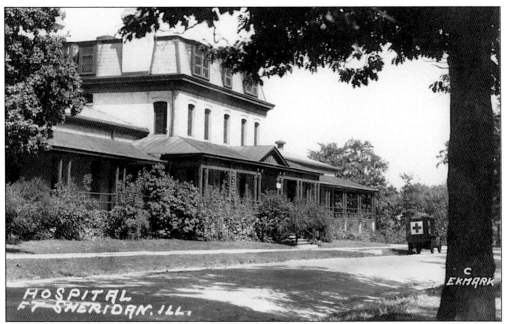

The post hospital was constructed in 1893, and from 1918-1920 grew into a multi-building complex to accommodate convalescing veterans, and thousands of civilians dying from the influenza outbreak. In 1967, this building was converted for use as the post library; a function it retained until the Fort's closure.

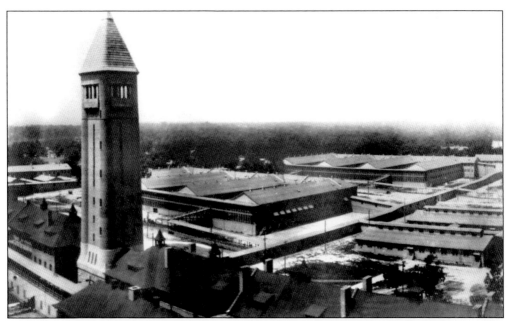

In 1918, Lovell General Hospital was constructed on the Fort's parade grounds to treat wounded and convalescent soldiers returning from the battlefields of World War I. This became the largest base hospital in the United States, and during its two years of operation (1918-1920) treated 60,000 patients, including civilians suffering from the Great Flu Epidemic of 1918.

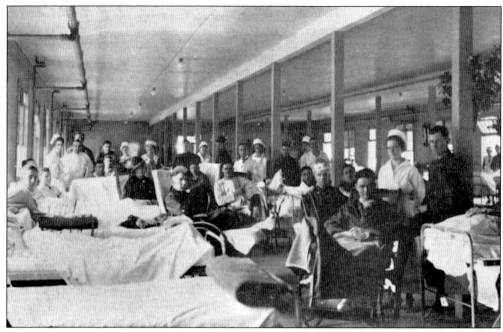

A view of one of the wards at General Hospital No. 28, later to be re-designated as Lovell General Hospital, treating convalescent soldiers of World War I, c. 1918.

Medics train for the realities of war, c. 1925.

The Color Guard transfers the colors, *c.* 1975.

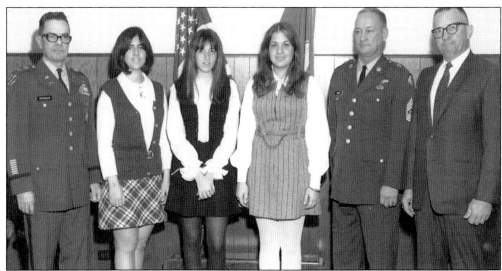

Niles North High School students Karyn Israel, Cindy Cohen, and Ann Hoffing, presented boxes of candy to be shipped to troops stationed in the Republic of Vietnam. Col. Edwin A. Nichols, commanding officer, accepted the boxes as Command Sergeant Major D.J. Quinn and Mr. Ray Carrell of Niles North High School witnessed the ceremony held on November 20, 1969.

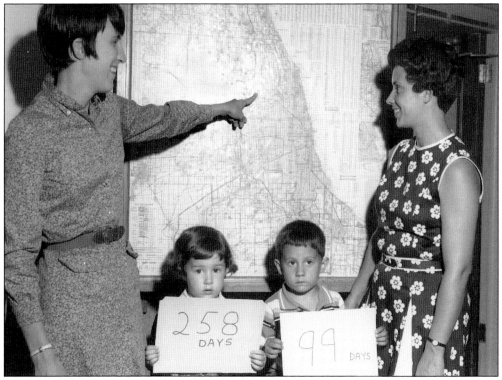

Donna Weddle (left) and Marilyn Burrow, members of the North Suburban Chicago Area Waiting Wives Club look at a map showing their home at Fort Sheridan. Their children, Karen Weddle and Stephen Burrow hold signs telling the number of days until their fathers' return home from service in Vietnam, 1969.

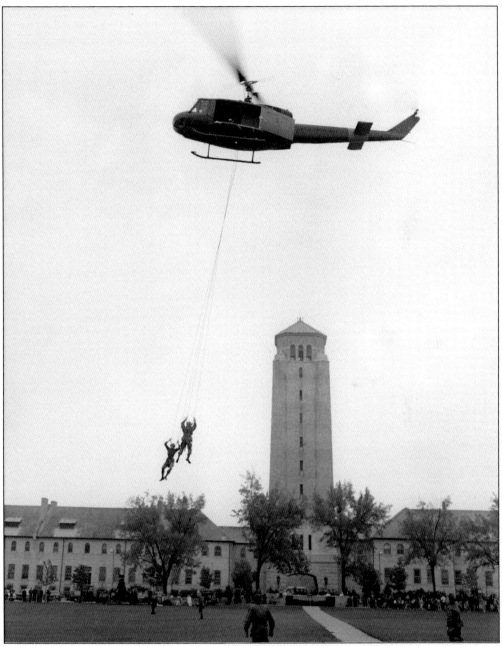

Members of the 12th Special Forces (Airborne) U.S. Army Reserve Parachute and Rappelling Demonstration Team make an entrance at Armed Forces Day ceremonies, 1973.

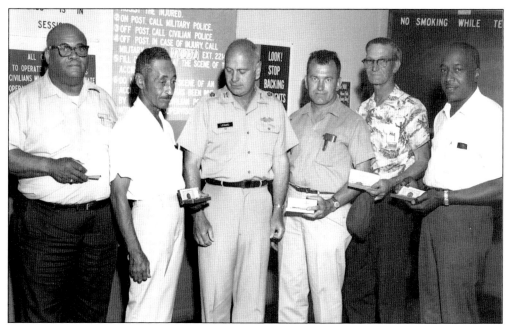

Colonel R.M. Leonard, commanding officer, presents 14-year medallions and awards for safe driving to Frederick D'English, William H. Day, Frank S. Chrusciel, Ralph E. Samuelson, and Verner Strickland, 1970.

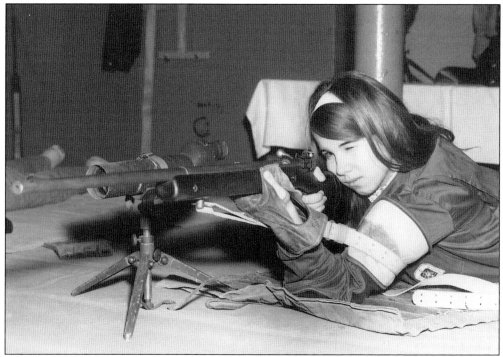

Jennifer L. Manning shows proper style as recipient of the pro-marksman, marksman first class, and sharpshooter awards at the National Rifle Association (NRA) Qualification Awards Ceremony, held at Fort Sheridan, February 1967.

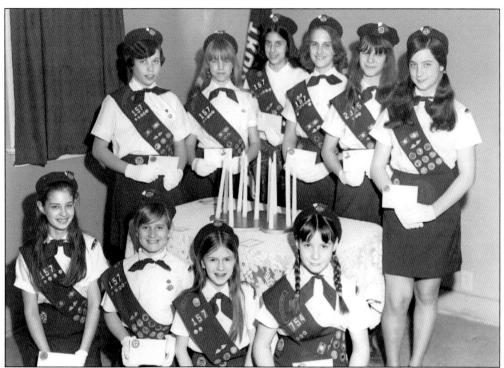

Fort Sheridan Girl Scout Troop 157 receive their merit badges, March 1970. Pictured sitting: Jackie De Thorne, Jeana Graham, Pattie Kapp, and Mary Compney; standing: Kim Kusick, Kathy Phillips, Nancy Peddle, Nancy Phillips, Alesia Smith, and Donna Marion. The Troop was headed by Helen Hugger and Eunice Elliott.

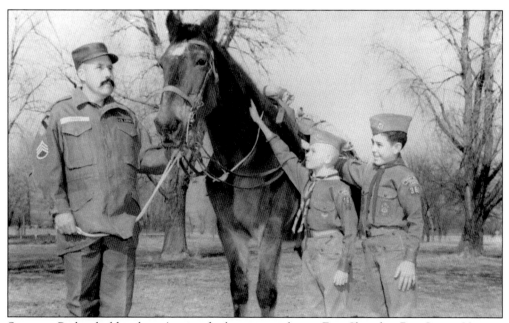

Sergeant Parker holds a horse's reins for boy scouts during Fort Sheridan Boy Scouts Visiting Day, c. 1960.

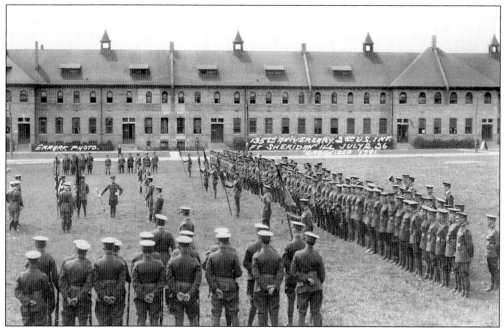

The 2nd U.S. Infantry celebrated its 135th anniversary in 1926.

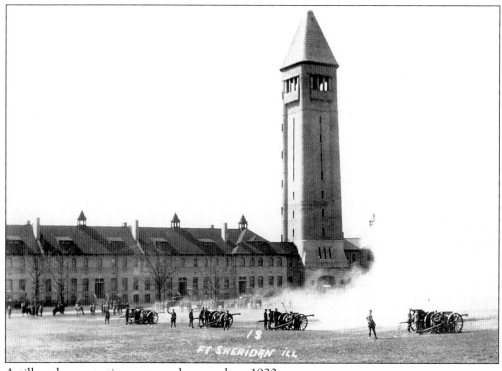

Artillery demonstrations on parade grounds, c. 1920.

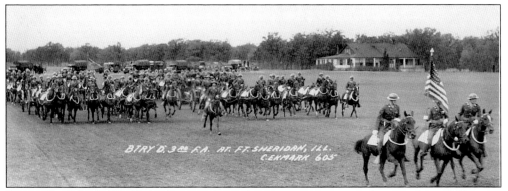

Battery D of the 3rd Field Artillery performs demonstrations on parade grounds, *c.* 1930.

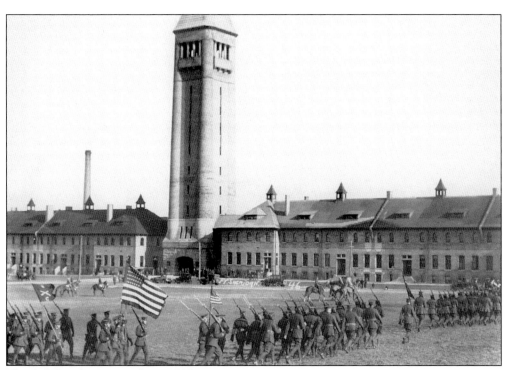

The 3rd Cavalry on parade, *c.* 1925.

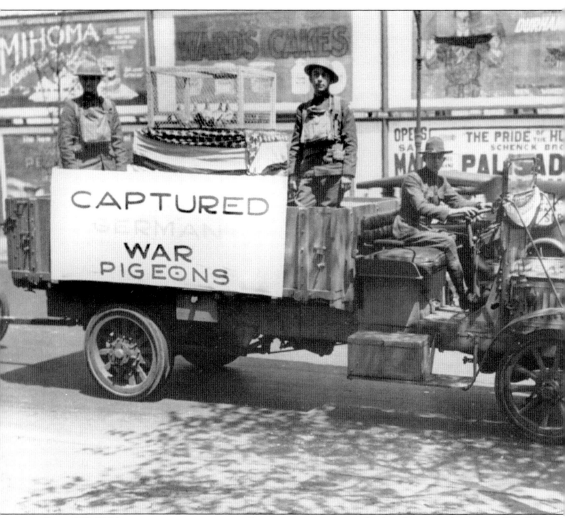

Over 100,000 homing pigeons were used to carry messages and take photographs during World War I with a success rate of 95 percent arriving at their destination. Due to unreliable radio and telegraph communication, pigeons became key to the success of troop movements. Captured German war pigeons appeared on parade, location unknown, c. 1917.

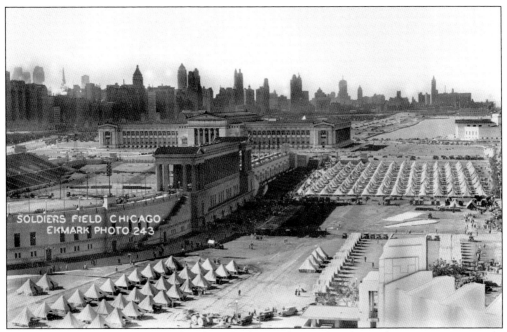

The architectural firm of Holabird and Roche designed Fort Sheridan and won a competition to design and build a new stadium in Chicago. Later to be named Soldier Field, the stadium opened in 1924 and hosted boxing matches, religious conventions, and military demonstrations. This aerial view shows Fort Sheridan troops encamped around Soldier Field, c. 1933.

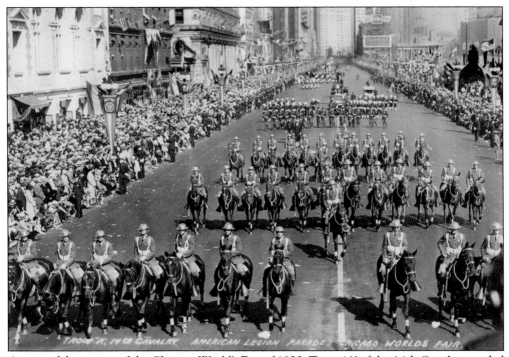

As part of the events of the Chicago World's Fair of 1933, Troop 'A' of the 14th Cavalry paraded down Michigan Avenue during an American Legion Parade.

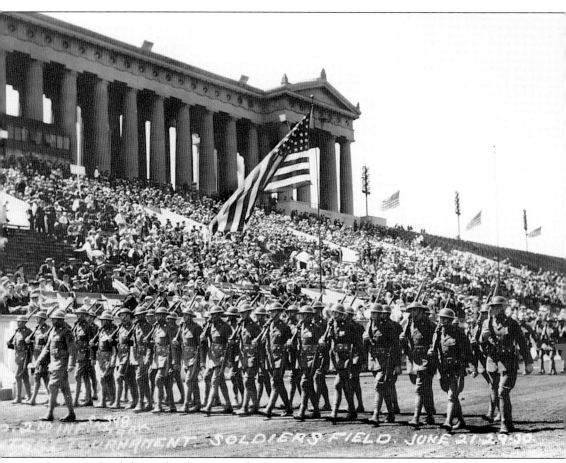

Company B of the 2nd Infantry parades at Soldier Field, June 1930. Holabird and Roche's design, which included the now familiar Doric colonnades, won them the competition to build the new stadium in 1924.

Four

You're in the
Army Now

A new arrival receives instructions at the Civilian Military Training Camp, c. 1926. These camps were incorporated into the National Defense Act of 1920 as a plan for domestic security. They were run by the Army and consisted of four weeks of intense training. Fort Sheridan conducted its first CMT camp in 1926.

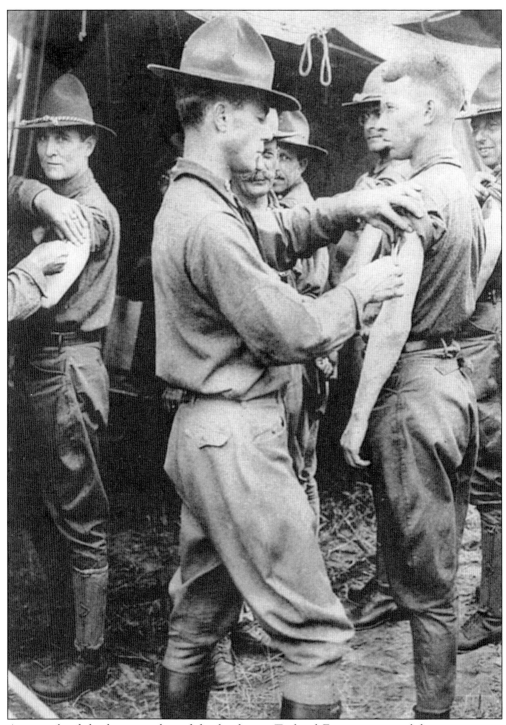

As a result of the large number of deaths due to Typhoid Fever contracted from unsanitary conditions during the Spanish-American War (1898), the U.S. Army implemented new sanitary practices and compulsory vaccinations. A new recruit is vaccinated during basic training at Fort Sheridan, c. 1925.

Capt. Jon Smith, medical doctor, examines a West Point Military Academy candidate at Fort Sheridan, 1968.

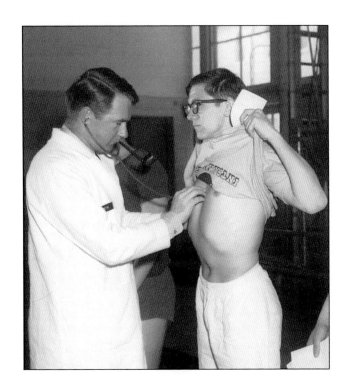

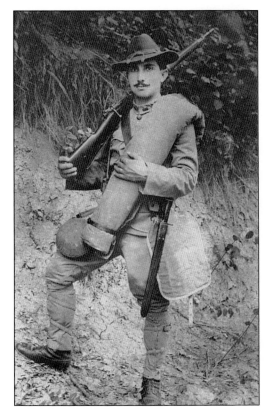

Pvt. Felix A. Russo is pictured here in 1909. Russo was in Company D of the 27th Infantry before being transferred to the Regimental Band.

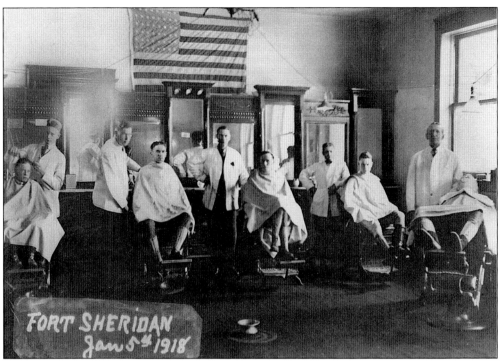
Cavalrymen visit the barber shop at Fort Sheridan, January 5, 1918.

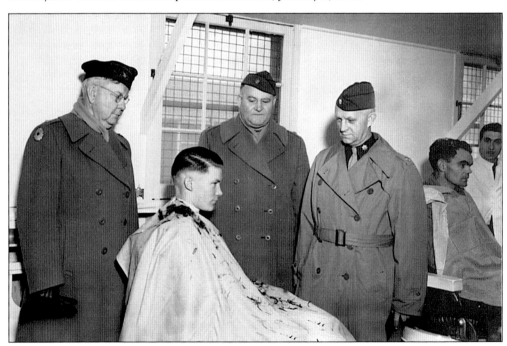
A scene in the Recruit Reception Center Barber Shop. Private Stanley Brady emerges from the scissors with the regulation two-inch cut. His new haircut is inspected by Lt. Col. Fred Distelhorst, Post Executive Officer; Lt. Col. Jefferson C. Campbell, Commanding Officer of the Recruit Reception Center; and Col. John T. Rhett, Post Commander.

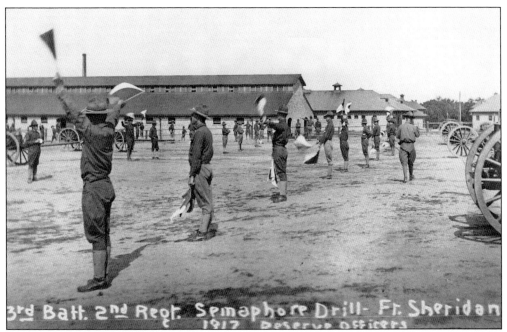

3ʳᵈ Batt. 2ⁿᵈ Reot. Semaphore Drill- Ft. Sheridan
1917 Reserve Officers

Wireless communications were still in their infancy during World War I, so the available methods included telephone, semaphore, signal lamps, carrier pigeons, and runners. Pictured is the 3rd Battery 2nd Regiment Semaphore Drill, 1917.

The first tank designs were essentially armored cars with a turret-mounted machine gun on the roof. From this evolved the modern tank with moving tracks and a heavily armored exterior. The first use of tanks on the battlefield was the Mark I built by the British and used at the Battle of the Somme, France, 1916. Though these early tanks malfunctioned more than not, they marked a move toward technology, and away from cavalry in battle and a reliance on manpower. During World War II, tanks played a key role in winning the war for the Allies.

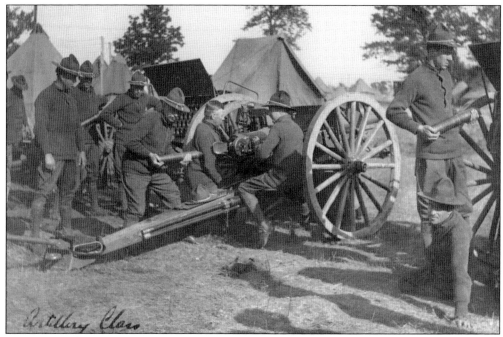

An artillery class gets hands-on training, c. 1925.

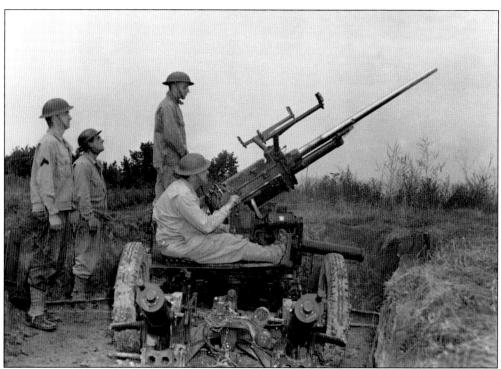

Beginning in 1920, Fort Sheridan was an Air Defense Artillery Training Center. During World War II, the Fort provided coastal artillery and anti-aircraft training. Pictured is a 37 MM anti-aircraft gun in action, 1942.

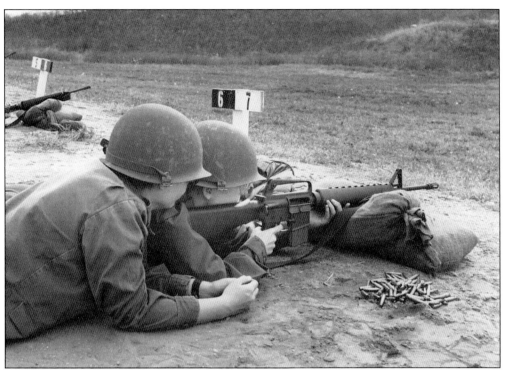

Artillery and firing ranges were located at the north and southeast ends of the Fort. A soldier fires an M-16 at a target range station, c. 1970.

Soldiers train with anti-aircraft equipment, c. 1942.

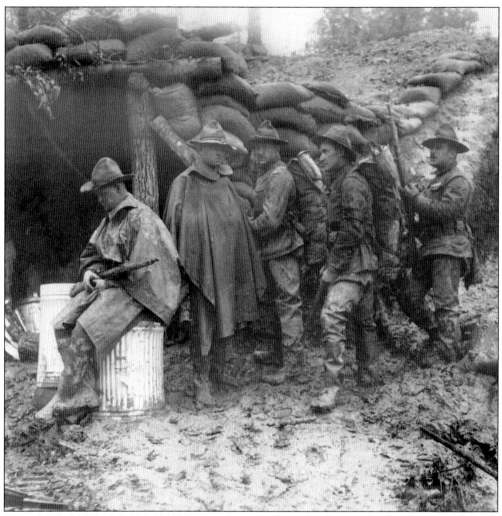

Though World War I (1914-1918) began dramatically with advances by the Germans through Belgium and France, a stalemate set in quickly with both the Germans and the French and British Allies digging trenches in order not to lose ground. By 1916, the United States had begun to train and enlarge its army in preparations for war. At Fort Sheridan much of the training focused on mastering trench warfare.

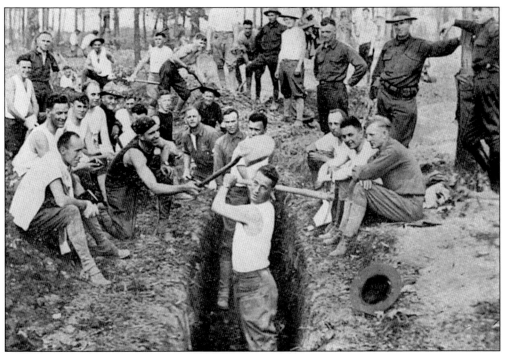

During World War I, soldiers constructed and used an extensive trenching system on the southeast side of the Fort, simulating, as closely as possible, the trenches and battle conditions in Europe.

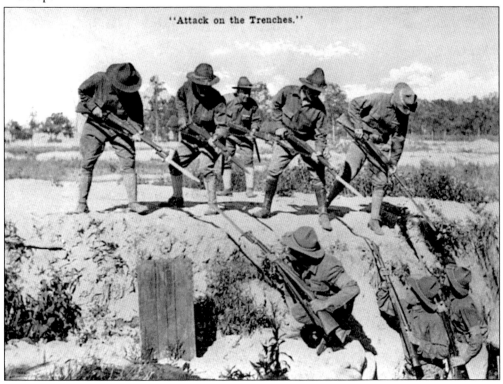

"Attack on the Trenches."

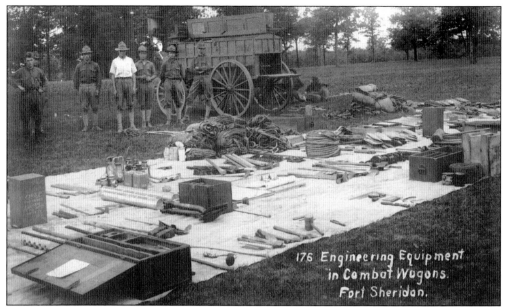

Army engineers were the first U.S. soldiers sent to Europe during World War I. Engineers suffered casualties while working to clear passages through forests and build roads and bridges for U.S. military troops.

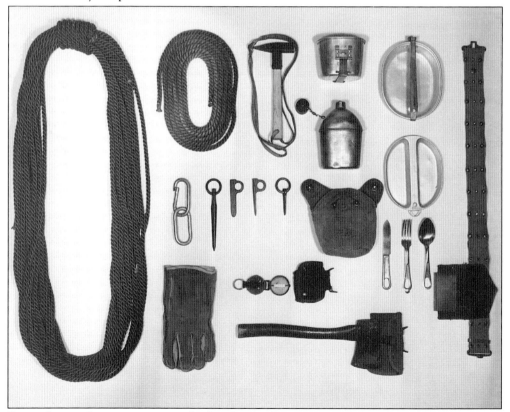

Personal gear of an army engineer displayed *c.* 1917.

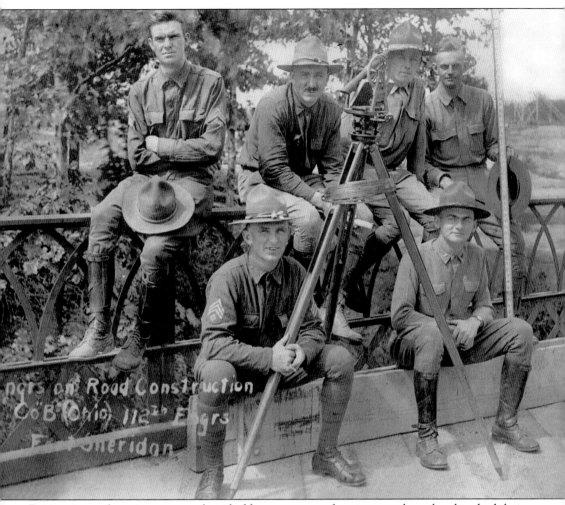

During times of war, it was not unheard of for a company of engineers to be ordered to shed their vehicles and engineer equipment and reorganize to fight as infantry. Pictured are engineers from Company B of the 112th Engineers of Cleveland, Ohio. In the summer of 1917, they surveyed and engineered a new military road along the bluffs at Fort Sheridan. The construction was completed by civilian contractors.

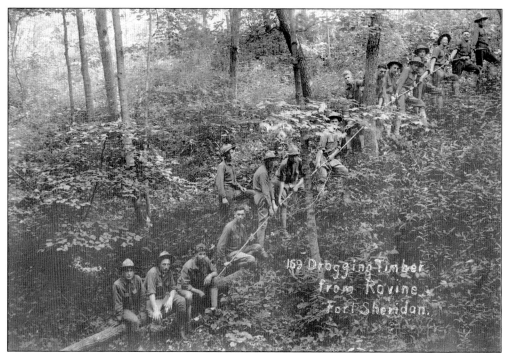

Pictured are engineers dragging timber from a ravine, and beginning the framework for a lock spar bridge, Fort Sheridan, 1917. Landscape architect Ossian C. Simonds considered the Fort's ravines a key element in his landscape plan for the site. The conservation-minded Simonds understood the value of native vegetation and did his best to preserve it, but he most likely did not envision the Army's training uses for these areas. Today, the Lake County Forest Preserves is restoring the Fort's ravines.

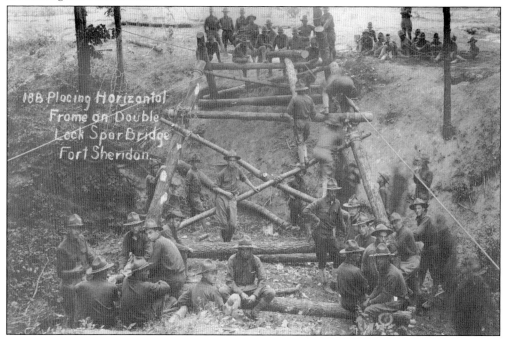

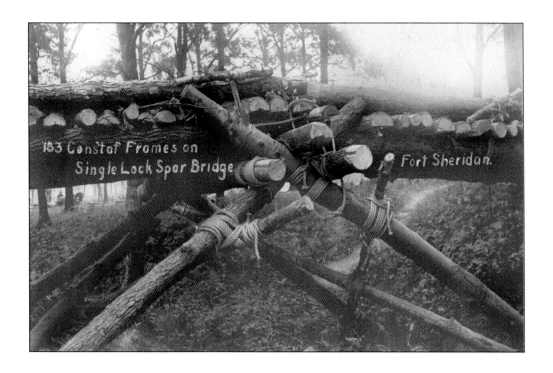

In the process of training at Fort Sheridan, engineers built several bridges across the ravine south of the main barracks. Completed bridges by Company B of the 112th Engineers of Ohio, Fort Sheridan, 1917, are shown above and below.

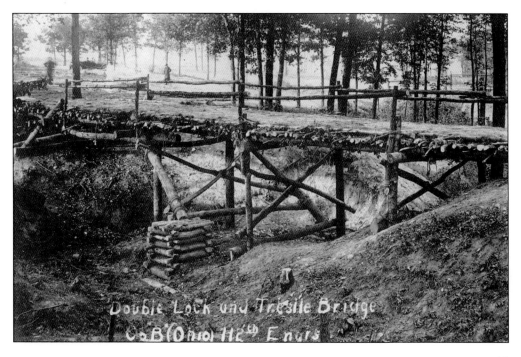

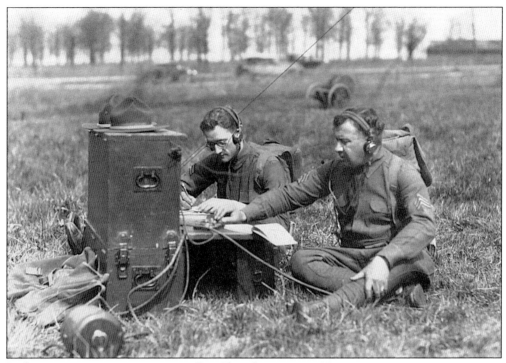

Radio communications operators at Fort Sheridan train *c.* 1924.

Soldiers use equipment in the communications school, *c.* 1925.

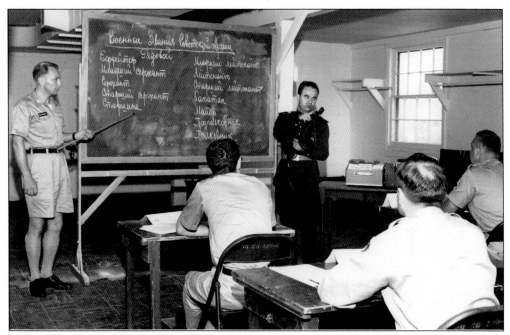

Maj. Walter M. Kuznecoff, instructor of the Russian language class, points to a list of words designating various commissioned and non-commissioned ranks in the Soviet Army. At right, Sgt. Jerome Stachniw, also a faculty member of the Department of Russian Language, is dressed as a Soviet Senior Sergeant and demonstrates a Soviet submachine gun for added emphasis, 1963.

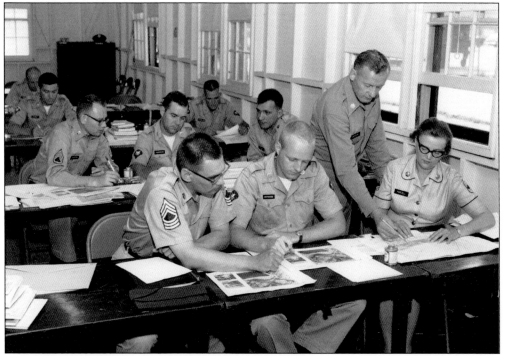

Army Photo Interpretation class with instructor Maj. John C. Malton observing students who are learning to interpret serial photo mosaics and flight plans for reconnaissance aircraft.

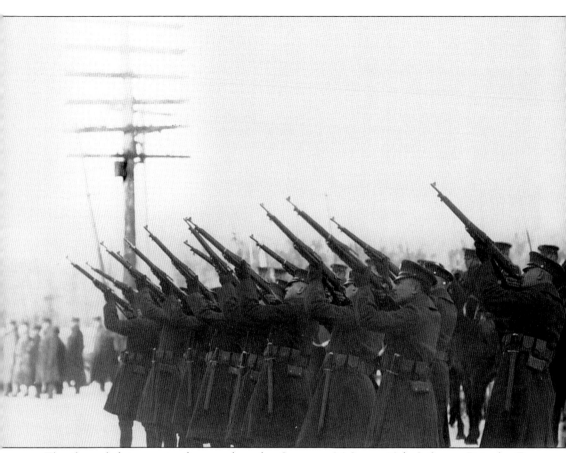

The funeral firing party fire a salute for Sergeant McLure, 12th Infantry Brigade, Fort Sheridan, 1924.

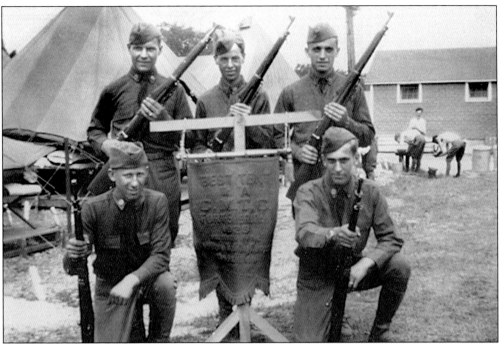

The award for "Best Tent at the Civilian Military Training Camp" was presented by the Military Training Camp Association, 1928.

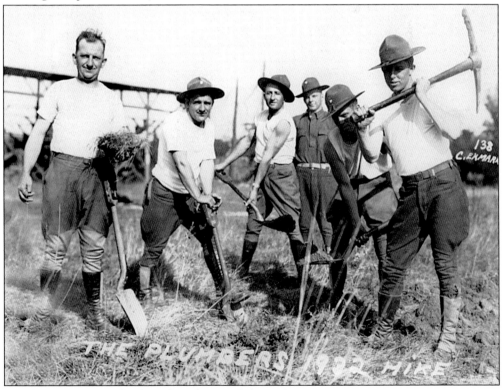

Cavalrymen are on "plumber" duty during a hike, 1932.

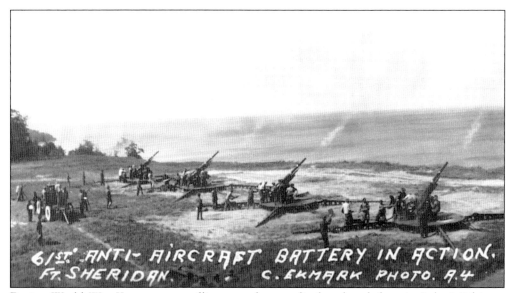

During World War II, over one million rounds were fired and ended up in Lake Michigan, including rounds fired by the 61st Anti-Aircraft Battery, c. 1940.

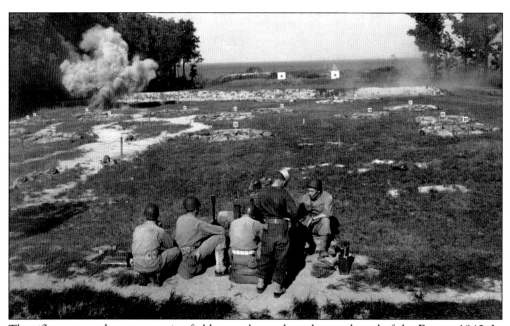

The rifle range and target practice fields were located on the north end of the Fort, c. 1940. In the early 1950s, much of the practice area was taken over by the airfield runway.

Fort Sheridan troops being addressed, c. 1935.

More than 30 percent of Americans wounded in World War I were gas casualties from the five kinds of poisonous gases used in the war. Gases blistered exposed flesh and caused rapid or, worse, gradual asphyxiation. The memory of this prompted the U.S. to take precautions for World War II, making gas mask training compulsory. Soldiers prepare to go into the gas chamber once located on the shoreline southeast of the Fort's tower, c. 1935.

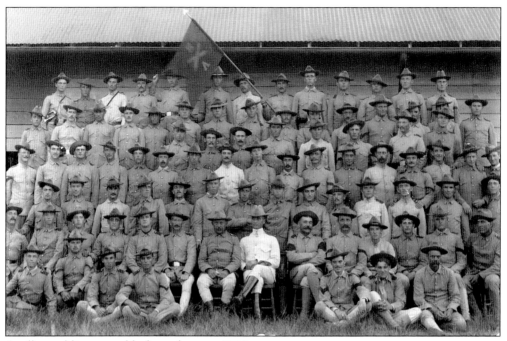

Artillery soldiers assemble for a photo, *c.* 1900.

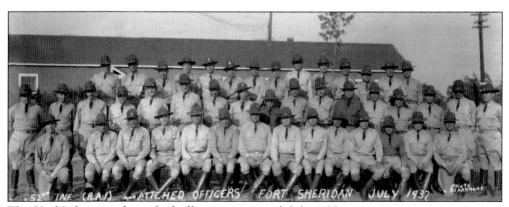

The 52nd Infantry and attached officers are pictured, July 1937.

Five

WOMEN'S ARMY CORPS

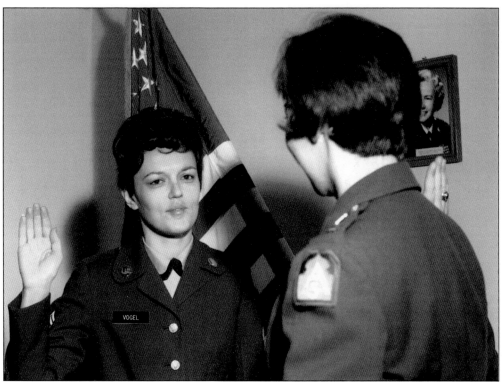

On May 14, 1942, President Roosevelt authorized the formation of the Women's Auxiliary Army Corps (WAAC). Fort Sheridan was the second base to receive a group of women soldiers. The Corps gained full military status as the Women's Army Corps (WAC) in June 1943. Pictured in this 1969 re-enlistment ceremony is Staff Sgt. Linda K. Vogel, and conducting the ceremony is Capt. Cyrene E. Margolis, Commanding Officer of the Fort Sheridan WAC Detachment.

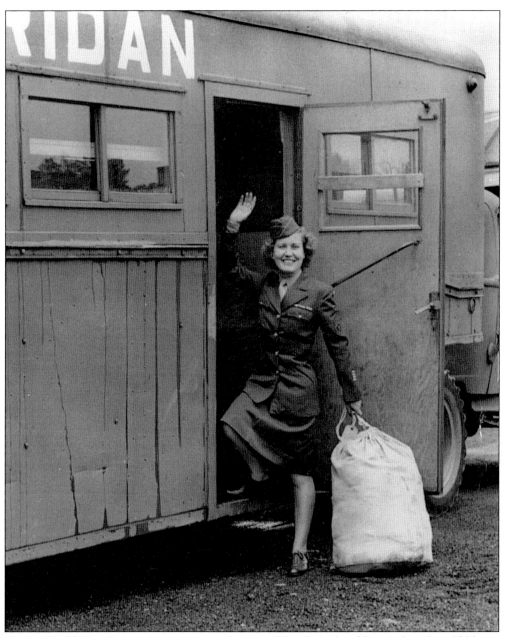

During World War II, American women volunteered for clerical and hospital work, sold liberty and war bonds, were parachute riggers, aerial photo analysts, and even trained servicemen in aviation gunnery. Like their male counterparts, women wanted to help in the war effort any way they could.

Beginning in October 1940, men between the ages of 21 and 35 were drafted for military service in anticipation of the U.S. going to war. Later, with the war on two fronts, in Europe and the Pacific, the war effort faced an acute manpower shortage. In response, the Women's Army Corps was created.

WACs arrived at Fort Sheridan in December 1942, and in November 1943 were joined by one of the first African American WAC detachments.

Gas mask training became compulsory after the horrors of gas warfare in World War I. WACs trained in the use of gas masks in simulation chambers as part of their coursework on chemical warfare, and some studied gas identification in Officer Candidate School.

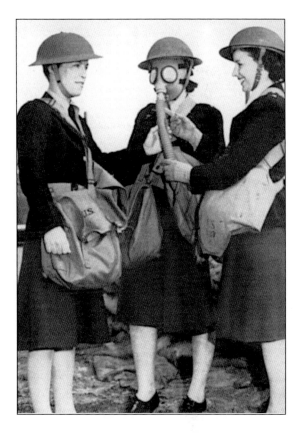

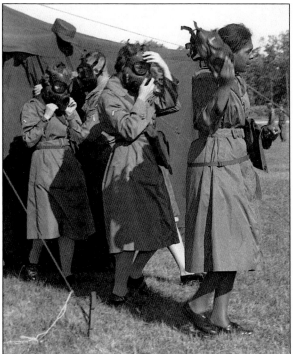

Overseas during wartime, military personnel, nurses, and civilians were legally required to carry gas masks at all times. In this image from 1964, WACs are going through the basic gas chamber training at Fort Sheridan. To this day, researchers work to increase protection for military personnel against greater varieties of biological and chemical weapons.

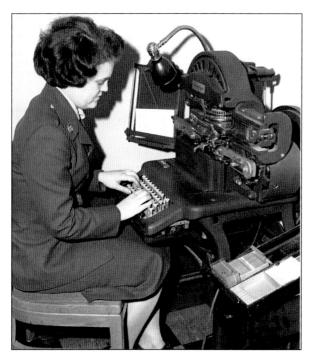

WACs were employed in many clerical positions, including graphotype operators. Pvt. Judy Phelps is shown making dog tags, c. 1950.

There was a great deal of opposition to women joining the armed services. During World War II, letters home from enlisted men criticized female soldiers. Enlisted soldiers tended to question the morals of any woman attracted to military service and passed those beliefs onto their families back home. Many of these soldiers had never seen a WAC, but the idea of women in the military meant that things had changed at home, and that was difficult for some men to accept, c. 1942.

This 1969 picture shows Yolanda R. Jones, Marion C. Crawford, and Elva J. Miller checking the WAC welcoming booklet. The WAC detachment was headquartered in the general purpose administration building, Building 81. This building is located at the west end of tower row. It was designed by the Quartermaster General and constructed as cavalry barracks in 1905.

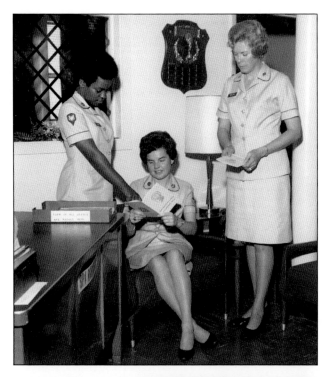

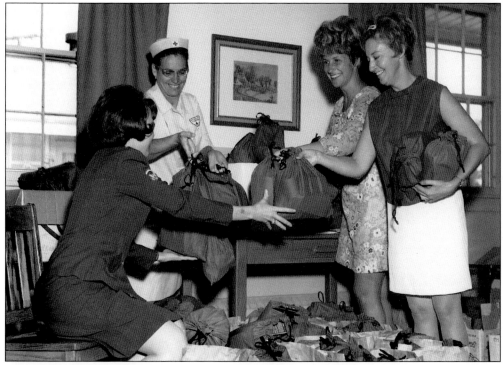

During the Vietnam War, WACs aided in the collection of ditty bags for servicemen and women overseas. Pictured here is WAC Patricia Sogan, receiving ditty bags prepared by the non-commissioned officers' wives club at Fort Sheridan, 1969.

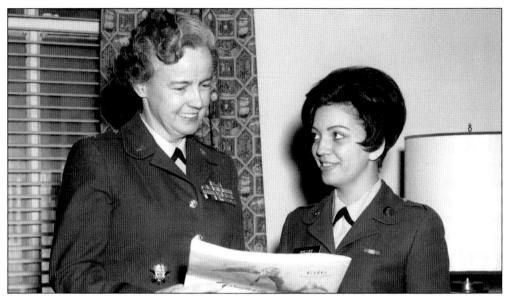

Col. Elizabeth Hoisington, WAC director from 1966-1971, is pictured on her 1967 visit to Fort Sheridan, discussing the post newspaper with Pvt. Donna Marie Gilley. Hoisington retired as a Brigadier General in July 1971.

The director was the primary adviser to the secretary of the Army on WAC matters and was responsible for ensuring that the Army's staff agencies issued appropriate plans and policies concerning the supervision, morale, health, and safety of WACs. The director ensured conformity in regulations and policies by inspecting WAC units and personnel worldwide.

During World War II, over 150,000 women served as WACs. They aided the American war effort by performing non-combatant military jobs and therefore freed men to serve in combat. Pictured is a WAC and an army officer at Fort Sheridan, c. 1942.

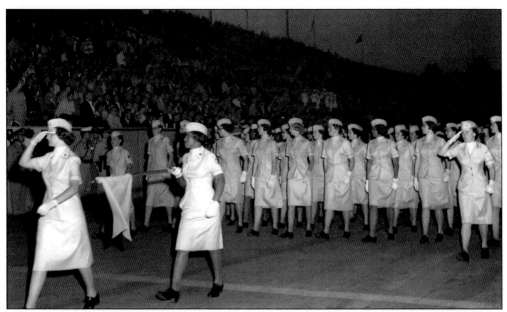

WACs parade at the 18th annual Armed Forces Benefit Football Game at Soldier Field, Chicago, Illinois in August 1963. WAC unit commander Lt. Judith Cornell is saluting Gen. Earle Wheeler. She is followed by flag bearer Sp-5 Jimmie Walker.

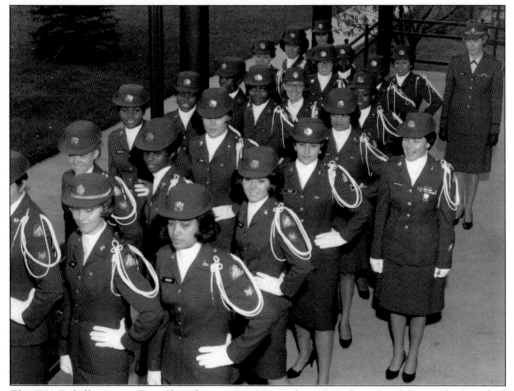

The WAC drill team at Fort Sheridan pose in November 1968. First Sgt. Marion C. Crawford (front right) is the drill team commander, and Maj. Elva Miller looks on.

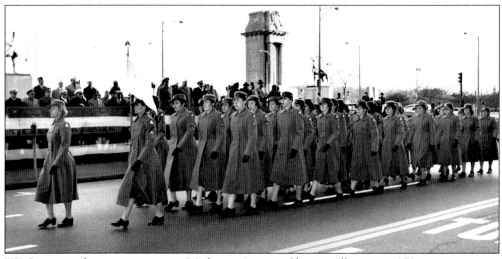

WACs on parade pass in review on Michigan Avenue, Chicago, Illinois, c. 1958.

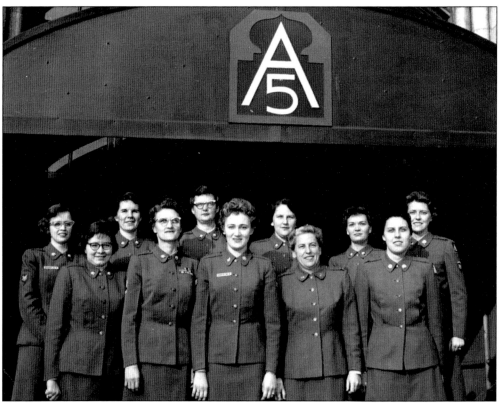

Fifth Army WACs stand in front of 5th Army Headquarters in Chicago, Illinois, 1959. The Women's Army Corps, as a separate corps of the Army, was discontinued in 1978. Women now serve as part of the regular army. Today, over 200,000 women serve in active duty in all branches of the military, and 150,000 serve in Reserves and National Guard units.

Six

VIPs and POWs

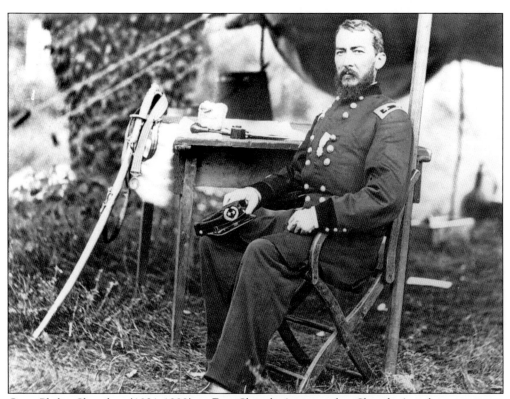

Gen. Philip Sheridan (1831-1888) is Fort Sheridan's namesake. Sheridan's military star rose quickly during the Civil War, and afterward he was assigned to the Division of the Missouri headquartered in Chicago. On October 8, 1871, when the Chicago Fire destroyed 18,000 buildings and left thousands homeless, Chicago Mayor Roswell Mason declared martial law and put Sheridan in charge. Sheridan's troops built temporary shelters for the homeless and restored order. Sheridan then became a key player in the successful efforts of Chicago's Commercial Club in establishing a permanent military base near Chicago. In 1888, as commanding general of the United States Army, he issued the order naming the new post Fort Sheridan in his honor. He visited the Fort in May 1888 and died a few months later after suffering a series of heart attacks.

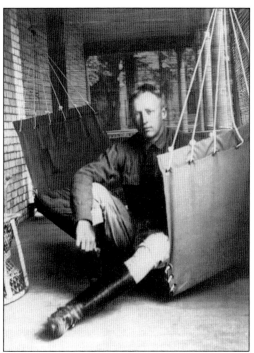

George S. Patton Jr. (1885-1945) was stationed at Fort Sheridan from 1909-1911. He is pictured here on the front porch of his home, Building 92, on Leonard Wood Avenue.

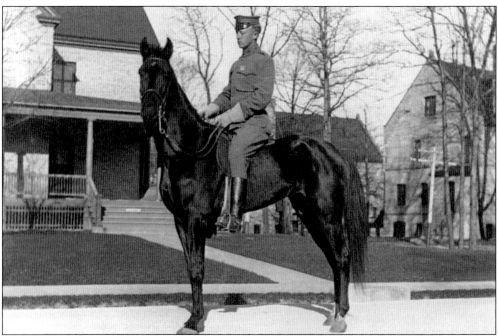

After graduating from West Point, Patton's first assignment was with the 15th Cavalry at Fort Sheridan. A good horseman and polo player, in 1917, Patton became one of the first men detailed to the newly established Tank Corps of the United States Army and was assigned the task of organizing and training the 1st Tank Brigade near Langres, France. Along with the British tankers, he and his men achieved victory at Cambrai, France, during the world's first major tank battle in 1917.

Patton became an outspoken advocate for tanks, even before many military and political leaders saw their value in warfare. When the German Blitzkrieg on Europe began in 1939, Patton convinced Congress that the United States needed a more powerful armored striking force. Patton went on to become the United States' leading genius in tank warfare. He commanded the Western Task Force in the Allied invasion of North Africa in November 1942, the Seventh Army during the invasion of Sicily in July 1943, and was given command of the Third Army in France in 1944. An imaginative and shrewd military commander, Patton is remembered as one of the most colorful and successful generals in United States history.

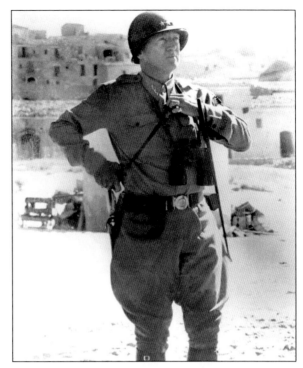

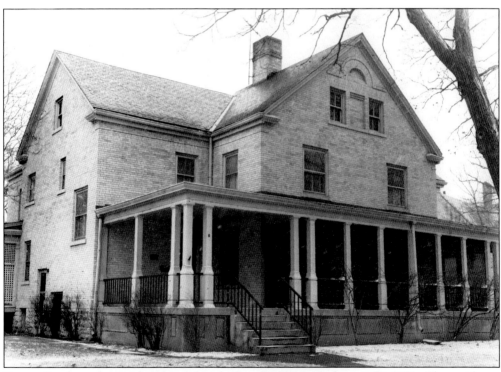

Patton lived on the north side of this duplex, Building 92, from 1909-1911. The residence was constructed in 1905 as two-family Lieutenants Quarters based on Quartermaster General architectural plans.

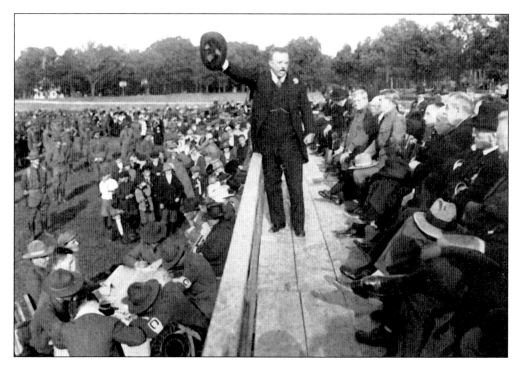

In 1914, with the outbreak of World War I, former president Theodore Roosevelt (1858-1919) visited Fort Sheridan to give a passionate speech about the importance of rallying troops for mobilization for the war. During the Spanish-American War, Roosevelt volunteered as commander of the 1st U.S. Cavalry, known as the Rough Riders. As president from 1901-1908, Roosevelt's "Square Deal" domestic program initiated welfare legislation, encouraged the growth of labor unions, and enforced government regulation of industry. He was significant in getting the Panama Canal built to stimulate American commerce, and in preserving natural areas for future generations. After his two terms in office, Roosevelt remained at the forefront of American politics until his death.

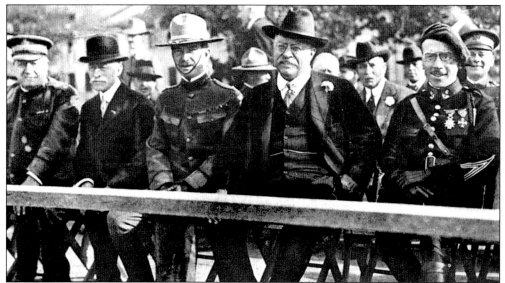

Vice President Charles G. Dawes is seen here at a ceremony at Fort Sheridan, 1926. Dawes (1865-1951) devised the "Dawes Plan" to salvage Europe's post World War I economy for which he received the Nobel Peace Prize. He is considered one of the best vice presidents in U.S. history, despite accomplishing very little during his term (1925-1929) due to his poor working relationship with President Calvin Coolidge. Dawes lived in Evanston, Illinois, and his home, the Dawes House, is a National Landmark.

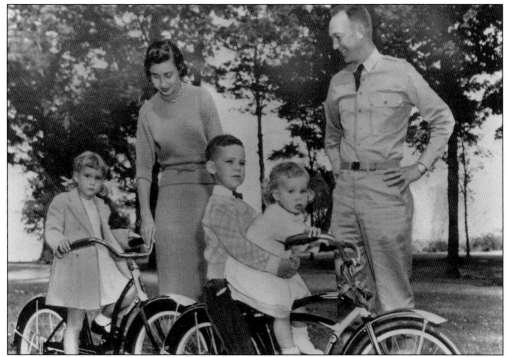

Maj. John Eisenhower (1922 –), President Dwight D. Eisenhower's son, is shown here with his wife and children at Fort Sheridan on his return from Korea, 1953.

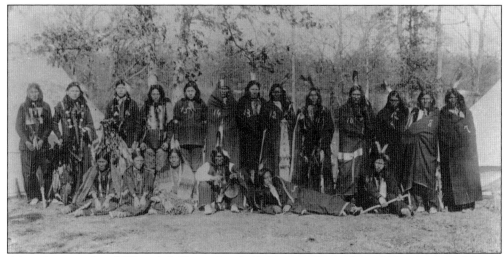

After the tragedy of Wounded Knee, South Dakota in December 1890, a group of Sioux warriors were escorted to Fort Sheridan in order to impress on them the strength of the U.S. military. Pictured in this George E. Spencer photograph are Kicking Bear, High Eagle, Revenge (19), Hard to Hit, Short Bull (5), Good Eagle, Close to Lodge (14), Standing Bear (11), One Star (15), White Horse (17), Run By (3), Lone Bull (12), Come and Grunt (6), Scatter, Plenty Wound (2), John Shengrau (interpreter), White Beaver (1), John Bree (interpreter), Take the Shield Away (18), Know His Voice (16), Sorrell Horse (9), and Horn Eagle (8).

Despite popular belief, the famous Sioux leader, Sitting Bull, did not visit Fort Sheridan. He was assassinated by Indian police on December 15, 1890, at Standing Rock, North Dakota.

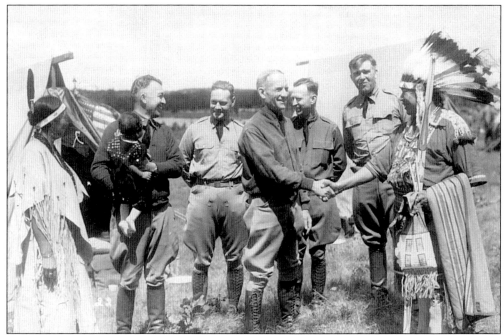

Colonel Brunzell of Camp McCoy greeted Chief Albert Yellow Thunder, a Winnebago (Ho–Chunk) leader, at Wisconsin Dells, 1932. Yellow Thunder (1878-1951) was a veteran of the Spanish-American War.

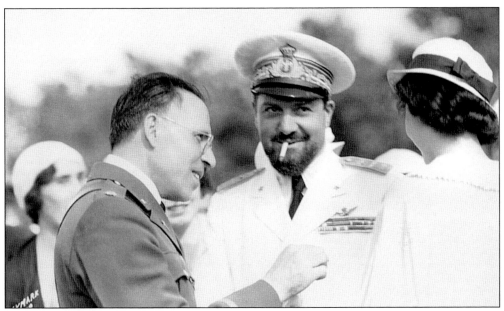

Italian fascist leader and aviator, Italo Balbo (1896-1940), made an appearance at Chicago's Century of Progress World's Fair in 1933. Balbo made aviation history by leading a group of 24 S-55 flying boats in a V formation from Italy to Chicago in just over 48 hours. Pictured is General Balbo (in white) with U.S. Army Chaplain Simoni at Fort Sheridan, during Balbo's historic visit.

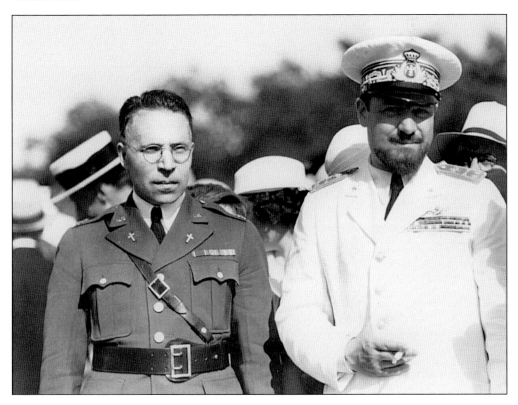

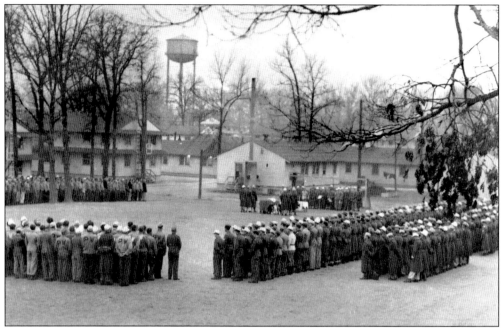

In 1944, Fort Sheridan assumed control of prisoner of war camps in Illinois, Michigan, and Wisconsin—or a total of 15,000 prisoners of war. German POWs are shown in this photograph, standing at attention in front of the newly constructed barracks at the Fort Sheridan POW camp located at the south end of the Fort.

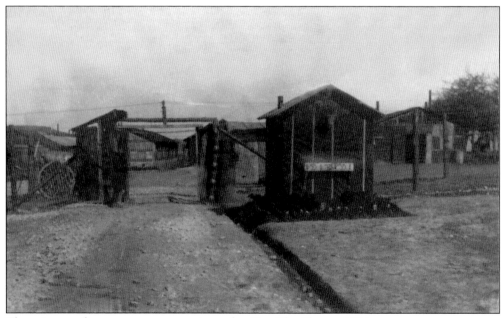

The prisoner of war camp entrance pictured at Fort Sheridan, c. 1944.

Pictured here is the guard tower at the prisoner of war camp, Fort Sheridan, c. 1944. The sign reads: "Restricted Area, prisoner of war camps, do not approach within 15 ft., no parking or loitering." The camp was surrounded by 8-foot-tall fences and watched by guards equipped with loaded machine guns.

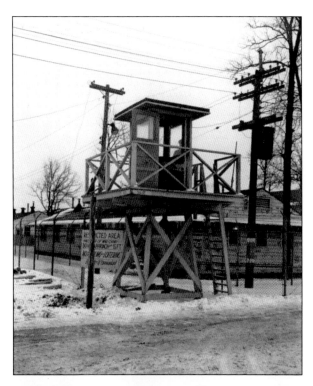

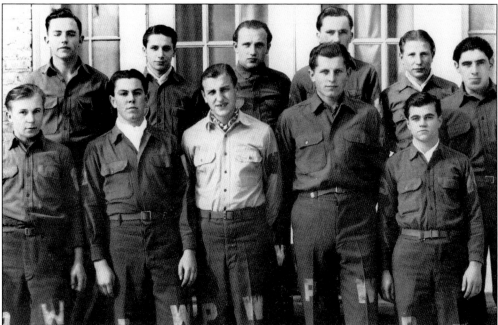

At Fort Sheridan, German prisoners served as cooks for prisoners and American soldiers, did janitorial work, picked up trash on post, washed dishes, and two even worked in the Fort's lab. All POWs were issued new clothing and given 80 cents a day in canteen coupons for their labor. The only lasting evidence of Fort Sheridan's role as a POW camp are the nine German POW graves in the Fort's cemetery.

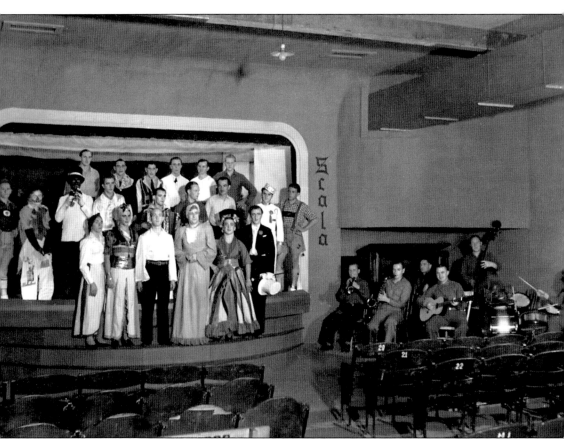

This photo of German POWs during a theatrical performance at Fort Sheridan, 1944, was taken by fellow POW, Sgt. Heinrich Drake. Drake was shot and taken prisoner by American soldiers while defending part of Italy's coast. At Fort Sheridan he was trained as a cook and returned to Germany after the war.

Seven

OFF DUTY

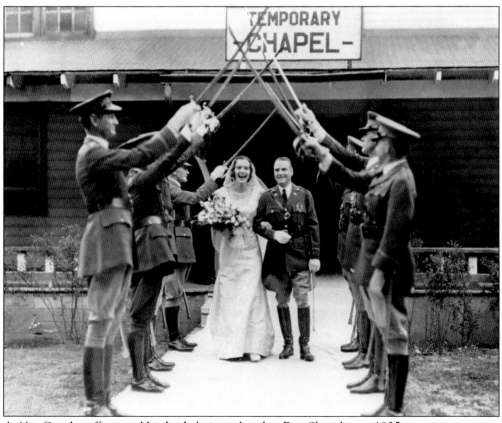

A 61st Cavalry officer and his bride being saluted at Fort Sheridan, c. 1925.

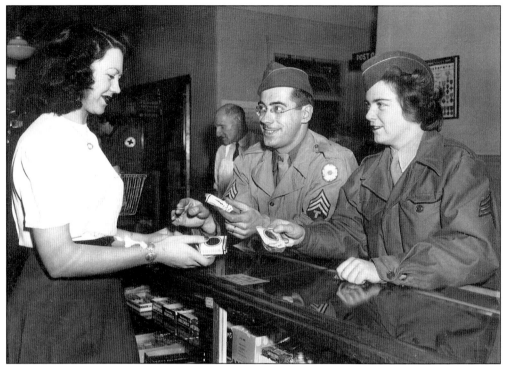

T-4 Raymond Prucha, and Sgt. Paula Gail Brown are pictured turning in empty cigarette packages to Mrs. Ann Guriali at the main post exchange, c. 1942. Rationing was a fact of life during World War II, impacting soldiers as well as the folks at home who were limited in the amount they could have of such items as sugar, meat, tires, gasoline, and cigarettes.

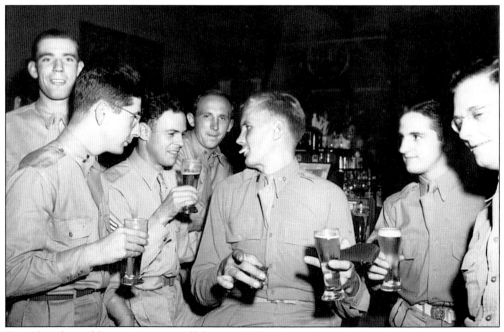

Fort Sheridan soldiers enjoy time off duty, c. 1945.

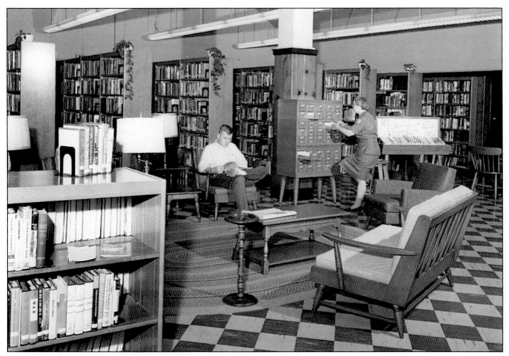

The post hospital was converted for use as the post library in 1967; a function it retained until the Fort's closure in 1993.

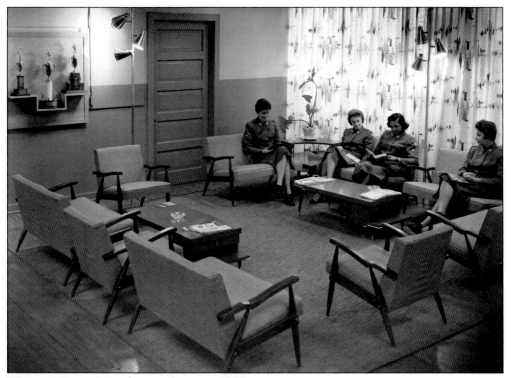

Women's Army Corps lounge shown in 1957.

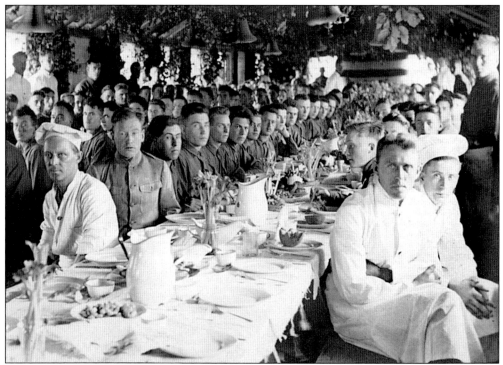

This was a "Farewell Dinner" for Company B of the 112th Engineers after completing training in the Officer Training Camp, September 29, 1917. These camps became the Fort's primary mission as set out by Gen. Leonard Wood who created the training camp program to prepare the men who would fight in future wars.

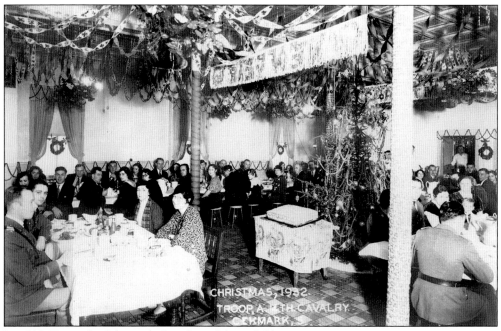

In 1932, Troop A of the 14th Cavalry celebrated Christmas.

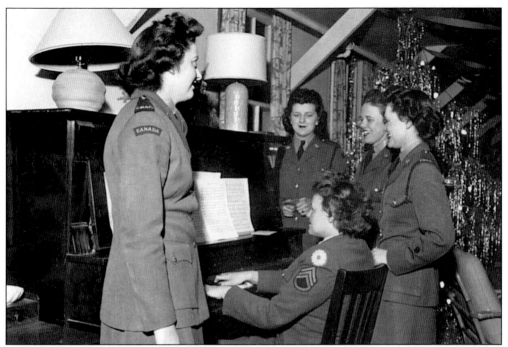

Sgt. Doris Champion, the mess sergeant of the Fort Sheridan Company A WACs, provided piano accompaniment for four Canadian CWACs who visited the Fort, c. 1944.

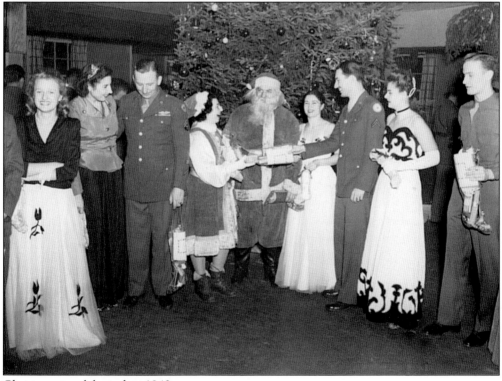

Christmas is celebrated, c. 1942.

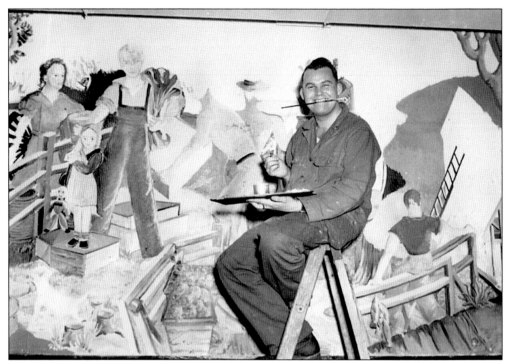

Pvt. 1st Class Philip Henselman of Medford, Oregon was a professional artist before his induction. He created a mural for the waiting room of the separation center medical section, *c.* 1940.

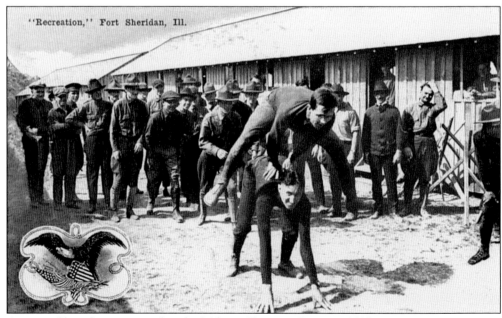

A game of leap frog is enjoyed at the Military Training Camp, *c.* 1917.

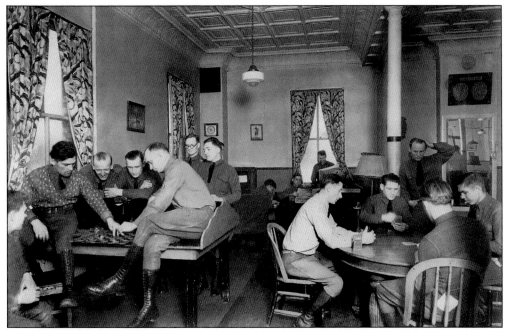

The recreation room of Battery D of the 3rd Field Artillery is shown, c. 1930.

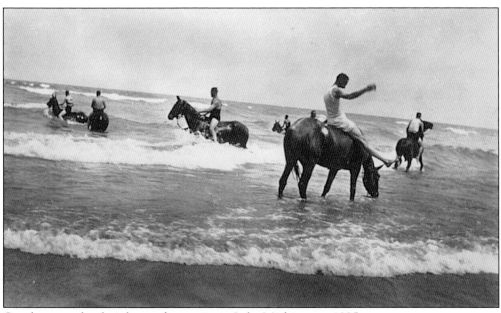

Cavalrymen take their horses for a swim in Lake Michigan, c. 1925.

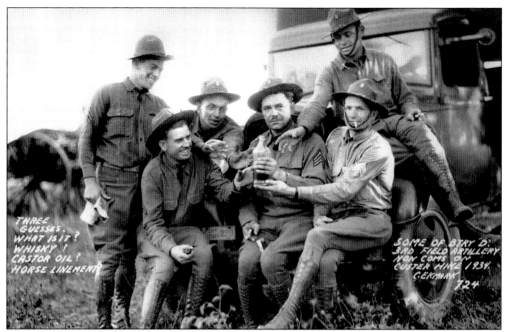

Members of Battery D of the 3rd Field Artillery pictured on a hike to Fort Custer in Kalamazoo, Michigan, 1934. The men are guessing what's in the bottle: "Three guesses. What is it? Whiskey? Castor Oil? Horse Linement [sic]?"

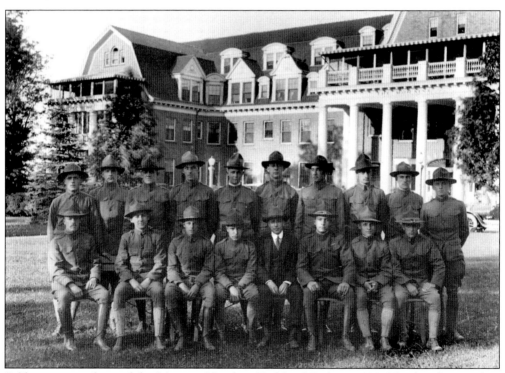

Soldiers pose in front of the Moraine Hotel in Highland Park, c. 1920. The hotel opened in 1900 and declared itself the "Waldorf–Astoria of the North Shore."

Soldiers recreated the patriotic "Spirit of '76" pose while on hike possibly near Sparta, Wisconsin, c. 1930.

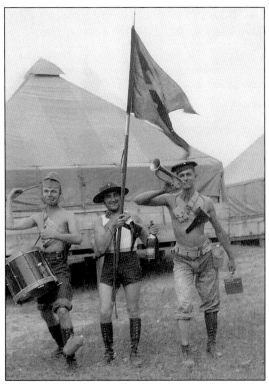

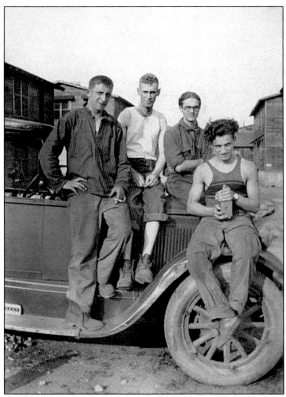

Enlisted men relax after a long hike to Camp Knox, Kentucky, June 1926. The camera the soldier is holding appears to be a Kodak No. 2A Brownie.

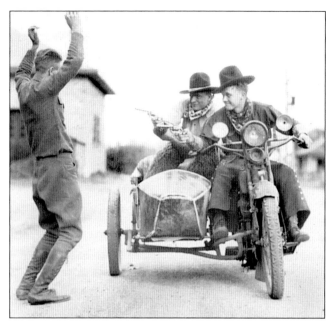

Cavalrymen, on a horse of a
different kind, had some "wild
west" fun at Fort Sheridan,
c. 1925.

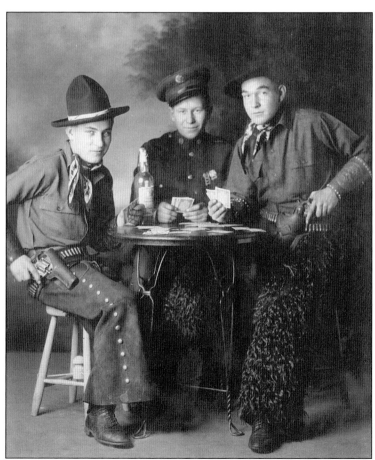

Cavalrymen in a
photo studio pose,
c. 1925.

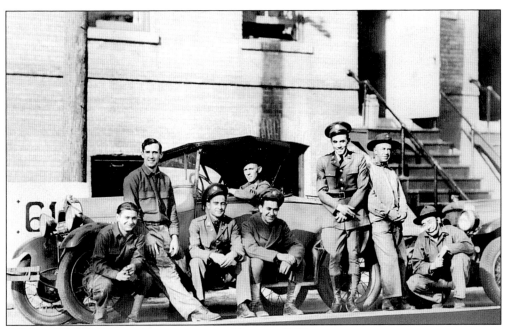
Off-duty Fort Sheridan soldiers are pictured here, c. 1930.

Soldiers take a break from duties, c. 1925.

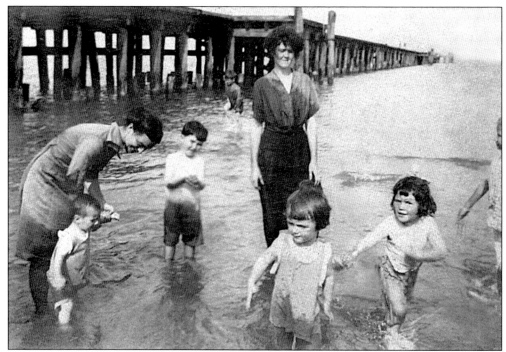

Soldiers' families enjoy the beach, c. 1915. The beach area near the pier was one of the more popular spots at the Fort. Picnics and cook-outs were common on weekends and holidays, and many people fished for perch off the pier to enjoy a "shore dinner" on the spot.

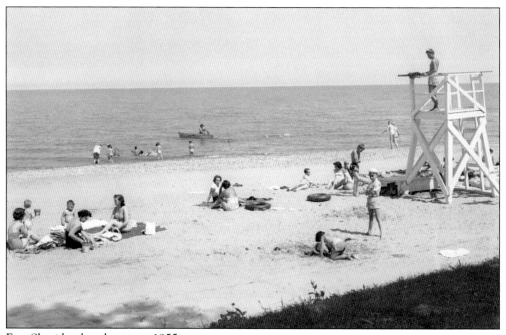

Fort Sheridan beach seen c. 1955.

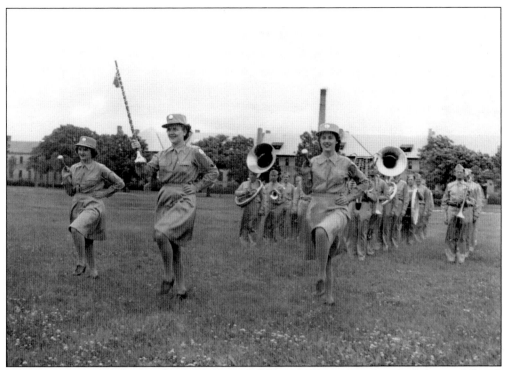

Drum majorettes Lucille Turigliato, Henrietta Wilson, and Leona Freehan lead the post's band, c. 1949.

Musicians pose, c. 1925.

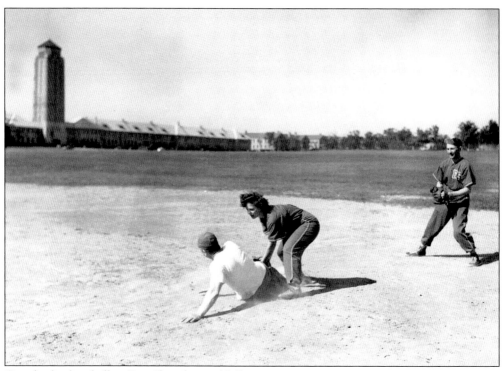

Co-eds play baseball at Fort Sheridan, *c.* 1949.

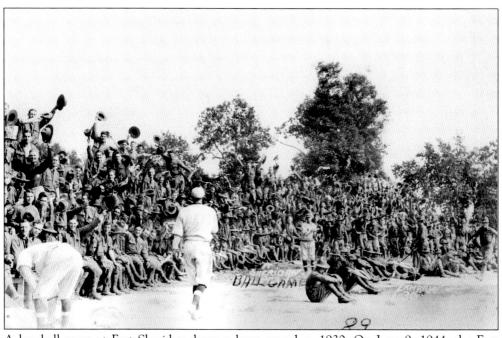

A baseball game at Fort Sheridan draws a large crowd, *c.* 1930. On June 9, 1944, the Fort Sheridan team played the Chicago White Sox at the Fort, beating them 8 to 6.

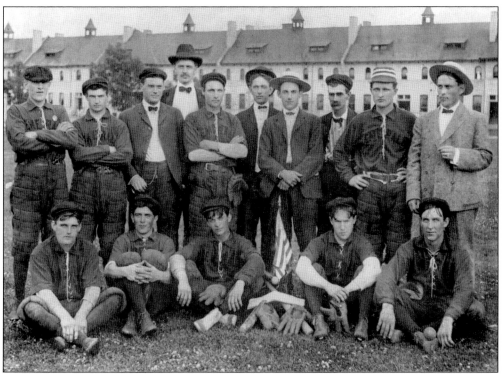

Modern baseball was developed in New York City and Brooklyn by Alexander Cartwright (1820-1892) who drew up the rules that became widely adopted for the game. Baseball probably first made its way to Lake County, Illinois, following the Civil War. Pictured here is the Fort Sheridan baseball team on the parade grounds, c. 1900.

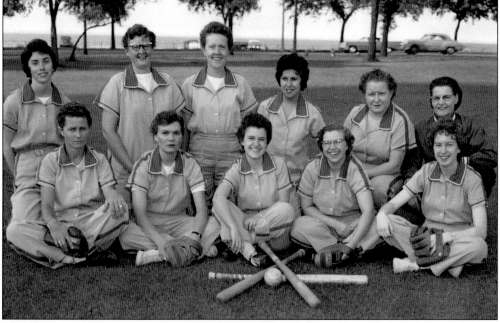

The Women's Army Corps softball team is pictured, c. 1956.

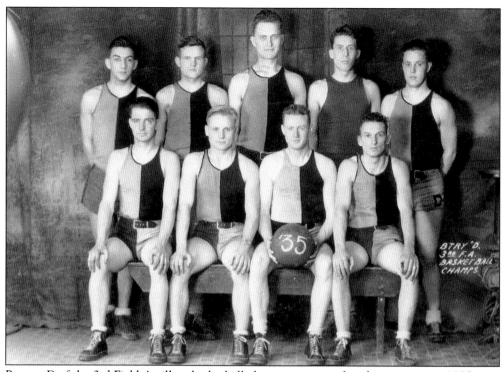

Battery D of the 3rd Field Artillery basketball champions pose after their victory in 1935.

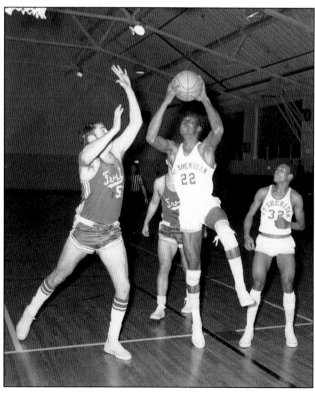

Post basketball game between the Fort Sheridan Ramblers and the Davidson Construction Company was played at the gymnasium, January 19, 1970.

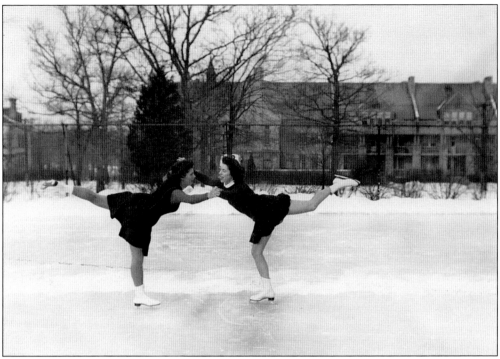

Women's Army Corps members Ann Bertos and Polly Wassen skate on an ice pond on the parade grounds, c. 1944.

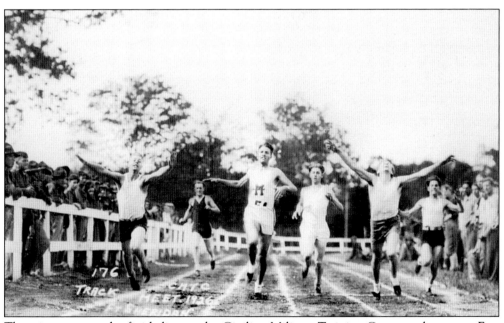

The winners cross the finish line at the Civilian Military Training Camp track meet at Fort Sheridan, 1926.

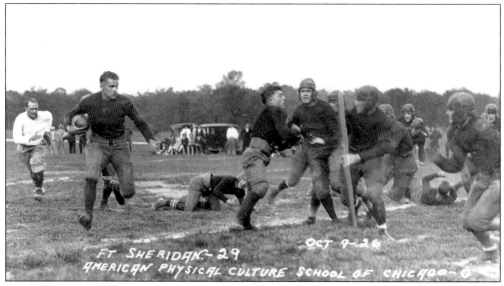

Football game action caught on film between Fort Sheridan and the American Physical Culture School of Chicago, October 9, 1926. Fort Sheridan won 29-0.

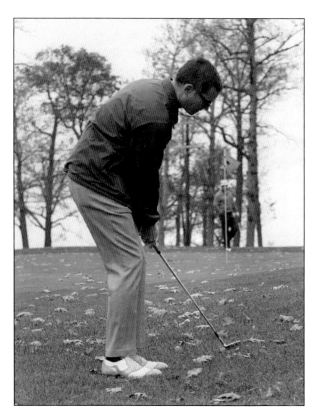

Teeing off at the Fort Sheridan golf course, c. 1970. The golf course, ravines, and cemetery—totaling 259 acres—were deeded to the Lake County Forest Preserves in 1998.

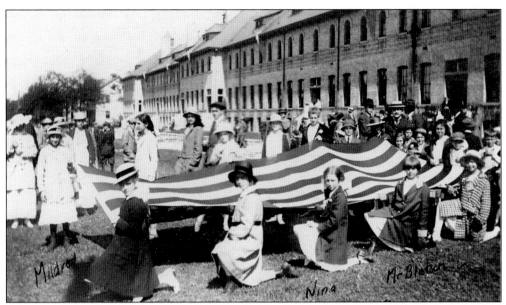

Decoration Day activities at Fort Sheridan, May 30, 1916. Memorial Day was originally known as Decoration Day and was first widely observed in 1868 as a time to decorate the graves of Civil War soldiers and to commemorate their sacrifice. After World War I, the holiday changed to honor Americans who died fighting in any war. In 1971, Congress declared Memorial Day a national holiday to be celebrated the last Monday in May.

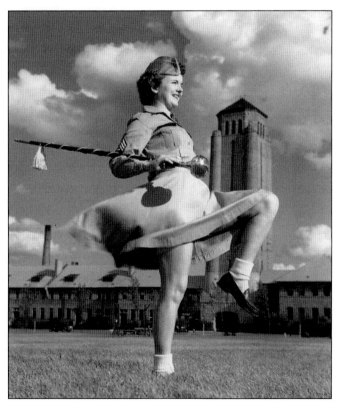

Drum majorette Henrietta Robinson is pictured on the parade grounds, c. 1949.

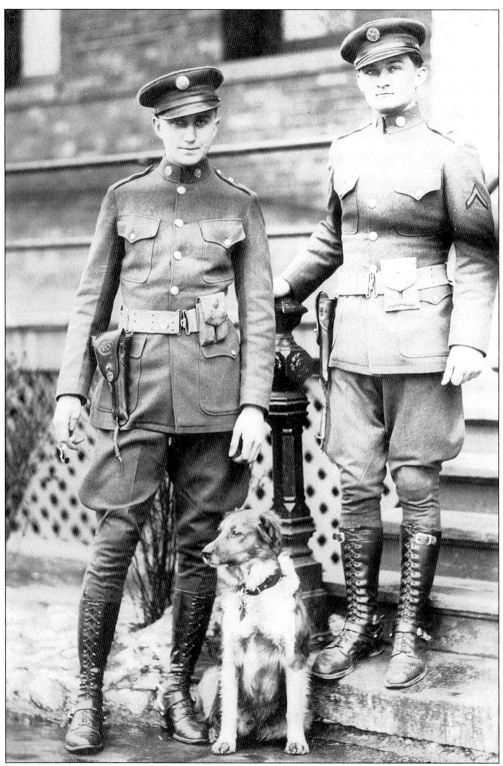

Cavalrymen pose outside barracks, *c.* 1925.